IMAGES
of Rail

SIERRA RAILWAY

D1731325

IMAGES
of Rail

SIERRA RAILWAY

Stephen D. Mikesell

ARCADIA
PUBLISHING

Published by Arcadia Publishing
Charleston, South Carolina

Printed in the United States of America

Library of Congress Control Number: 2015948911

For all general information, please contact Arcadia Publishing:
Telephone 843-853-2070
Fax 843-853-0044
E-mail sales@arcadiapublishing.com
For customer service and orders:
Toll-Free 1-888-313-2665

Visit us on the Internet at www.arcadiapublishing.com

*This book is dedicated to the men and women of
California State Parks who do so much to preserve the
most precious historical resources in California.*

CONTENTS

ACKNOWLEDGMENTS

The shops, yards, and equipment of the Sierra Railway are now owned and operated by the State of California as Railtown 1897 State Historic Park, with the additional support of nonprofit partner The California Railroad Museum Foundation. The management at the park, especially Supt. Kim Baker, have been most helpful in putting together this book. The records, including photographs, of the Sierra Railway are archived at the library of the California State Railroad Museum in Sacramento. The staff at the library, especially Cara Randall and historian Kyle Wyatt, offered invaluable assistance. Without them, this book would not have happened. The Tuolumne County Historical Society was also generous and helpful in putting together this history of its county. And, most of all, I need to thank the most talented editor in California—my wife, Suzanne.

INTRODUCTION

Railtown 1897, a California State Historic Park in the Mother Lode, is a legend among railfans, especially fans of steam railroads. Simply stated, Railtown 1897 contains one of the finest collections of railroad shops and steam-era rolling stock anywhere in the United States. This book concerns the Sierra Railway, which created the shops and bought or built most of the rolling stock currently in use at Railtown 1897.

Railtown 1897 is maintained by the California State Department of Parks and Recreation as a working adjunct to its equally famous California State Railroad Museum in Sacramento. Railtown 1897 is situated in the little unincorporated community of Jamestown, some 150 miles south and east of the California State Railroad Museum, in the foothills of the Sierra Nevada. The Sacramento museum displays a wide array of artifacts from railroads throughout California. Railtown 1897 tells the story of a single railroad, the Sierra Railway, and specializes in being a working railroad, not a static museum. Together, the two museums—the predominantly static museum in Sacramento and the working steam facility in Jamestown—produce an unparalleled picture of steam railroading in California history.

The Sierra Railway, however, assuredly did not begin life as a museum. The railroad was built in 1897 by wealthy entrepreneurs who sought to fill a most basic need—rail service in California's Mother Lode—and hoped to make some money in the process. As such, the Sierra Railway was similar to dozens of other short-line railroads built throughout California and the hundreds that were created throughout the United States. The Sierra Railway is important not so much because it carried the most freight or made the most money, but because it survived largely intact when most other steam lines were dismantled as railroads were converted to diesel-electric power in the 1950s.

The Sierra also converted to diesel—dieselized (the common term for this process)—in 1955. However, it elected to retain its vintage steam rolling stock as well as the shops needed to support that rolling stock for two simple but unusual reasons: the company was making money using its steam fleet and shops in support of the motion-picture industry, and railfans were trekking to Jamestown by the hundreds to ride excursions on this magical line. The movie business had an attraction to vintage railroads as early as the 1910s, and the Sierra Railway was one of the first working lines to realize the potential profits that could be made. As hundreds of movies (mostly Westerns) were filmed using the Sierra Railway, the railway's owners, looking for a way to survive as trucks took away much of their business, kept its steam fleet intact even after the freight business converted to diesel. Railfans, who had discovered the line as early as the 1930s, offered additional economic reason for the owners of the Sierra to keep the steam line open and operating.

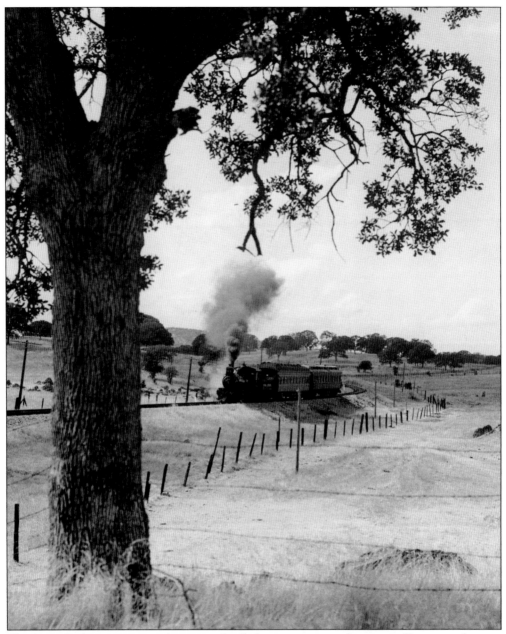

The Sierra Railway is a national treasure chiefly because its steam heritage still exists and is now open for public enjoyment as part of the California State Parks system. The photographs in this book give readers a hint of the magic of Railtown 1897 and its steam equipment and excursions. Those perusing this book are advised to read it, then do the obvious thing: go to Railtown 1897, located in the picturesque and remote California Gold Rush town of Jamestown, and experience this magic firsthand. No words, no photographs can take the place of that! (California State Railroad Museum.)

One

THE FOUNDERS OF THE SIERRA RAILWAY

The Sierra Railway did not begin life as a museum or a movie set. It started in 1897 as a workhorse railroad designed to move the freight of the extractive industries, chiefly mining and lumber, of the Sierra Nevada and its foothills to ports and markets elsewhere. The men who organized the line recognized that in the days before good roads and trucks, it was nearly impossible to fully exploit the minerals or the lumber of the Sierra Nevada without access to a railroad that connected these remote operations with potential markets and supplies elsewhere in California, the nation, and the world.

The developers of the Sierra Railway were not museum operators, nor were they engaged in a philanthropic endeavor. They hoped to profit from the operations of the railroad itself, and they also hoped to profit from the industries the line would serve. As the Sierra Railway was built to one market or another, the owners were quick to buy up quality mining and lumber operations in the area, knowing these investments would increase in value almost instantaneously when railroad service began.

Three men—Thomas S. Bullock, Prince Andre Poniatowski, and William Crocker—willed and invested the Sierra Railway into existence. These three speculative investors continued to own and operate the line between its creation (in 1897) and the 1910s. At some point, however, the speculative profit ceased to exist, and the owners either sold their interest, died, or decided to operate the Sierra as a working railroad, without any real potential for speculative profits. By the end of the 1920s, control of the railroad was concentrated in the hands of W.H. Crocker, and to his heirs afterwards. The Crocker family sold the diesel Sierra Railroad to a private party in 1980 and sold the Jamestown property to California State Parks (for Railtown 1897 State Historic Park) in 1982; the family simultaneously donated all the railroad equipment to the state.

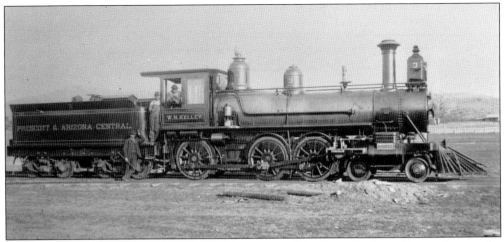

Thomas S. Bullock was the key figure in the creation of the Sierra Railway, because he was the most daring. Like many American entrepreneurs, he was born with little money, made a great deal of money, and died nearly broke. Before coming to California, Bullock had organized the Prescott & Arizona Central Railway (P&AC) in the 1880s. The P&AC was, by all measures, a failure. It lasted but a few years before it was bankrupted and given back to its principal investor, Thomas Bullock. The most valuable of the assets was the locomotive that would become Sierra No. 3. This locomotive, a 4-6-0 (four forward wheels, six driving wheels, and no trailing wheels), was built by Rogers Locomotive Works in 1891 and shipped to Arizona. When the P&AC failed, Bullock took it to California for work on the Sierra Railway. It is still in use today! This c. 1892 image offers a rare view of Sierra No. 3 when it was in use on the P&AC. (Sharlot Hall Museum.)

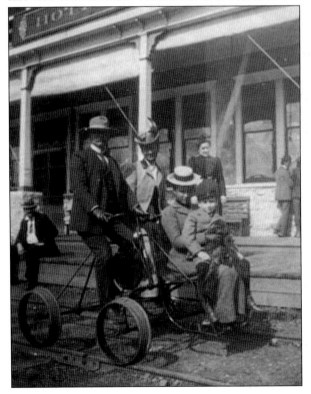

Bullock elected to take his locomotive, rails, and other assets to California with the intent of building a different short line that would provide a rail connection to an emerging market in what was called the Southern Mines—mines in the southern part of the Mother Lode in the foothills east of Stockton. Specifically, he was interested in providing access to the mines of Tuolumne County, which, in the 1890s, were beginning to be reactivated with new hard-rock mining methods. Bullock felt he could profit both by servicing existing mines and, potentially, by acquiring his own mines, which would grow in value as the railroad line was built. Shown on a pedal-powered track bike in front of the Hotel Nevills in Jamestown are, from left to right, T.S. Bullock, Mrs. Bullock, Mrs. S.H. Smith, and Jack Bullock. (Tuolumne County Historical Society).

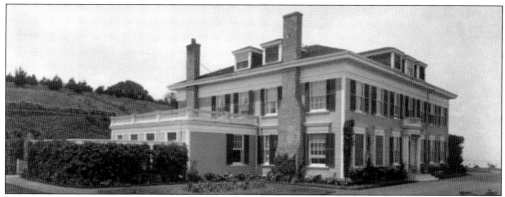

As he looked for a location for his railroad, Thomas S. Bullock noticed that another person, Andre Poniatowski, was investing in mining properties in the same counties. Bullock decided to bring Poniatowski into the proposed railroad line, where the two could benefit from increased value in mining properties. Often called Prince Poniatowski, because he was descended from the last royal family of Poland, Andre was actually born in France and trained as a banker. He came to California as a young man, hoping to learn from the bravado of American bankers. This is Poniatowski's home in Burlingame, California. (California State Library.)

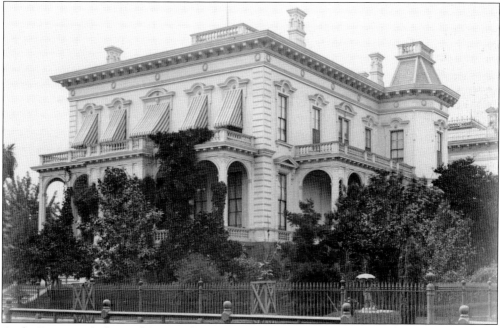

Andre Poniatowski learned from William Crocker, a leading figure of California banking, that a California banker was not an idle lender of funds but an active investor in industries with potential for growth. When Poniatowski decided to join Bullock in the railroad venture, he quickly turned to Crocker. With that, the leadership of the Sierra Railway was established. William Crocker, the son of Charles Crocker, one of the founders of the Southern Pacific Railroad, got to know Poniatowski in two ways. First, he helped introduce Poniatowski to the banking community in San Francisco. Second, he introduced Poniatowski to Elizabeth Sperry, the sister of William Crocker's wife, Ethel, and daughter of wealthy Stockton grain man Simon Sperry; Poniatowski would marry Elizabeth Sperry. This is the home where William Crocker came of age in Sacramento; it is now part of the larger Crocker Art Museum in Sacramento. (Library of Congress.)

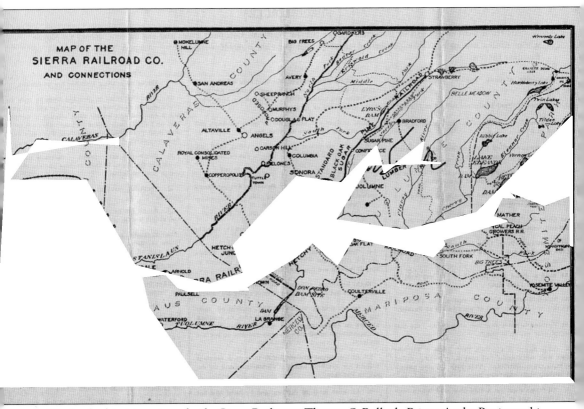

The leadership triumvirate for the Sierra Railway—Thomas S. Bullock, Prince Andre Poniatowski, and William Crocker—remained in place in the early decades of the 20th century. Eventually, Poniatowski sold his stake and returned to France. Bullock died with his share of the railroad diminished to little value. The family of Crocker, however, consolidated ownership and continued to operate the line for nearly a century, finally selling the property in the 1980s to two groups. One group was interested in operating a diesel freight operation, Sierra Railway. The other buyer was the State of California, which was interested in operating the steam equipment as a museum and recreational asset. This map shows the line of the Sierra Railway, or Sierra Railroad. (The change in nomenclature came about when the Sierra Railway went bankrupt in the 1930s and reemerged with the slightly different name.) The trackage of the line was at its peak just before the Great Depression. (California State Library.)

Two

BUILDING THE LINE
TO JAMESTOWN

Thomas Bullock came to California intent on reusing the remnants of the failed Prescott & Arizona Central Railway for a line leading to the Mother Lode of California. The mining country of the California foothills had boomed in the 1850s, but it fell into stagnation in the latter part of the 19th century. The area, however, experienced a small renaissance in the 1890s due to the introduction of industrial hard-rock mining methods to rework the old placer claims. Andre Poniatowski invested heavily in mining properties in Tuolumne County, as well as in Calaveras and Amador Counties. After he met Bullock, the two decided to work together to finance a railroad to the Mother Lode. Poniatowski enlisted the financial support of his wealthy brother-in-law, William Crocker, and the Sierra Railway was born and incorporated in early 1897.

At first, the three investors planned to build east from the deep-water port at Stockton. That town, however, was already well served by the Southern Pacific and would later be served by both the Santa Fe and Western Pacific Railroads. Realizing the Stockton port was already crowded, the leadership of the Sierra Railway selected as its western terminus the little town of Oakdale, located about 35 miles east of Stockton, in Stanislaus County. Oakdale had a small Southern Pacific depot that was built in 1897, no doubt in response to the beginning of construction on the Sierra Railway line. Rather than building a new station, the Sierra leased space in the Southern Pacific depot.

The Railtown 1897 property in Jamestown contained the original yards, shops, and headquarters for the Sierra Railway. This chapter chronicles how the Sierra Railway built its pioneering line to the Jamestown property.

The Oakdale depot building still exists and is now used by the Oakdale Cowboy Museum. Oakdale is home to one of California's best-known rodeos and is still the center of a very important cattle industry despite increasing suburbanization. The initial business plan for the Sierra Railway was to build some 35 miles east from Oakdale to the even smaller town of Jamestown. The business plan also called for building little stations along the way and to accept freight traffic even before the line reached Jamestown. (Photograph by Stephen D. Mikesell.)

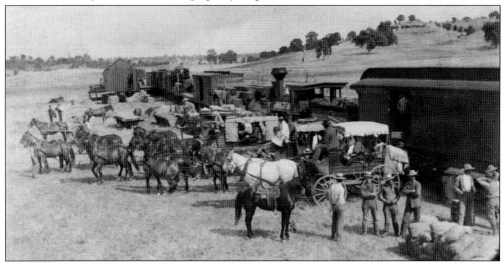

Work on the new Sierra Railway line was handled in part with crews and material that arrived by rail and in part with crews and material that arrived by horse and wagon, as shown in this 1897 photograph taken somewhere near what would become Cooperstown Station. The locomotive is Sierra No. 2, an ancient 4-4-0 built in the 1850s and used by Thomas Bullock on his Prescott & Arizona Central Railway. Amid this beehive of activity, supplies, including rails and ties, are being pushed to the site by No. 2. (California State Railroad Museum.)

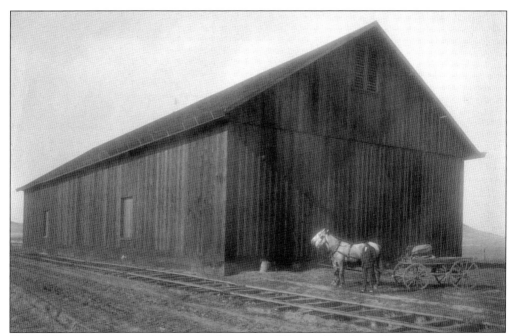

One of the earliest stations built on the line was at Warnerville, about 16 miles east of Oakdale. This photograph of a grain warehouse at Warnerville was taken in 1898, shortly after the freight shed was built. This large freight warehouse illustrates the intent of the Sierra Railway planners to begin freight service as soon as possible. In the early years of the line, farm products, especially grain and cattle, were a key part of the freight business. (California State Railroad Museum.)

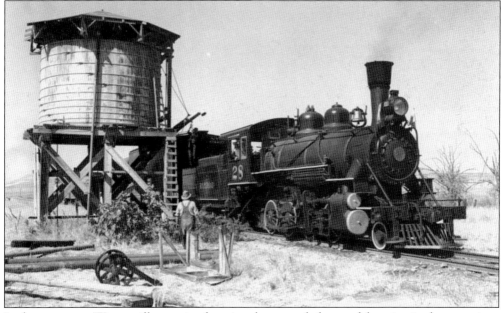

In the steam era, Warnerville remained a minor but nonetheless useful station in the operations of Sierra Railway. Here, the water tower at Warnerville is being used to fill the thirsty steam locomotive No. 28 in the early 1950s—a very late year in the use of steam on this line. (California State Railroad Museum.)

The next station beyond Warnerville was Cooperstown, 20 miles from Oakdale, the first stop to feature passenger service, including a passenger station. This 1898 view of Cooperstown shows the station and the rangeland surrounding it. As discussed in chapter 7, the Sierra Railway eventually became a favorite facility for filming Western movies. The excellent steam equipment of the line was the main attraction for filmmakers, but the open rangeland was also attractive, since it could be portrayed as Wyoming, New Mexico, or almost any other Old West locale. This photograph also shows how busy freight service was in the 1890s, based on the many boxcars along the siding. (California State Railroad Museum.)

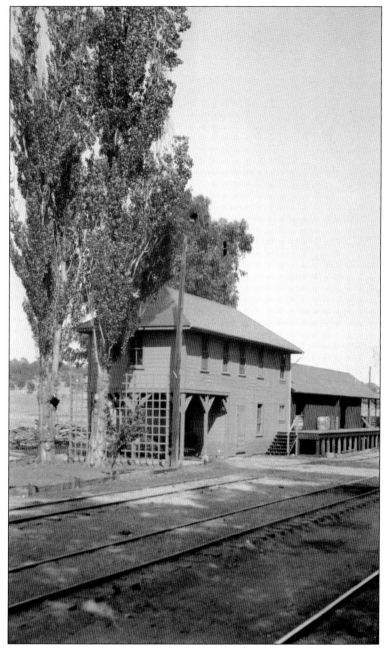

This is the station at Cooperstown. The stations between Oakdale and Jamestown were utilitarian—almost spartan in design—in stark contrast with a string of architecturally sophisticated depots and stations built in the Jamestown, Sonora, and Tuolumne areas in the following years. Cooperstown is essentially a place name today, although the station can still be used on the active Sierra Railroad freight line. In the 1980s, the Crocker family, owners of the old Sierra Railway, sold the remnants of the railway in two parts. The family sold the steam operation in Jamestown to the State of California for use as a park. They sold the diesel-electric freight operation to a private firm, and it now operates on the old Sierra Railway alignment as the Sierra Railroad. (California State Railroad Museum.)

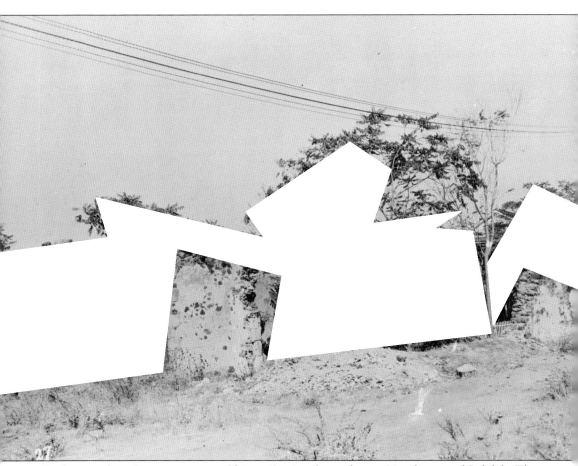

Farther east from Cooperstown was Chinese Station, located some 30 miles east of Oakdale. The station was a short distance from an old gold-mining town called Chinese Camp, which was a Chinese settlement during the Gold Rush. However, it was Chinese in name only by the time the Sierra Railway built through the area. By the late 1890s, the town was in serious decline. Although it was associated with a near-ghost town, Chinese Station was a key link in the Sierra Railway system, because it was the first stop that was near the emerging hard-rock mines, including the Eagle Shawmut Mine, which proved to be a good customer at Chinese Station. It was a virtual ghost town when a photographer for the Historic American Buildings Survey captured this image of the Bruschi Store in the mid-1930s. Today, Chinese Camp is nearly abandoned, with a population of little more than 100 persons. (Library of Congress.)

18

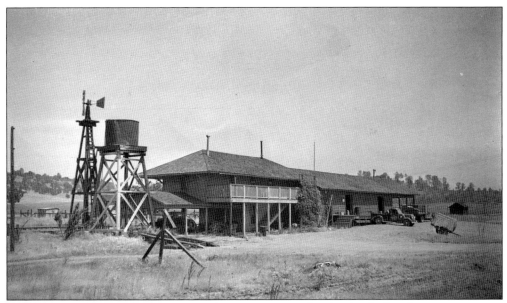

The station at Chinese Camp was a working structure with a freight shed and passenger station joined by a stationmaster's house, a water tower, and a windmill to feed the water tank. In later years, this station became a key junction between the Sierra main line and a branch that ran south to Yosemite National Park. This photograph of Chinese Station appears to have been taken in the mid-1920s. (California State Railroad Museum.)

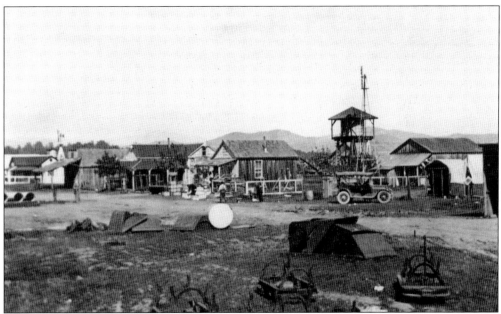

This 1916 photograph offers a more detailed view of the facility at Chinese Station. Other than the shops in Jamestown, this was one of the most complex facilities on the line. (Tuolumne County Historical Society.)

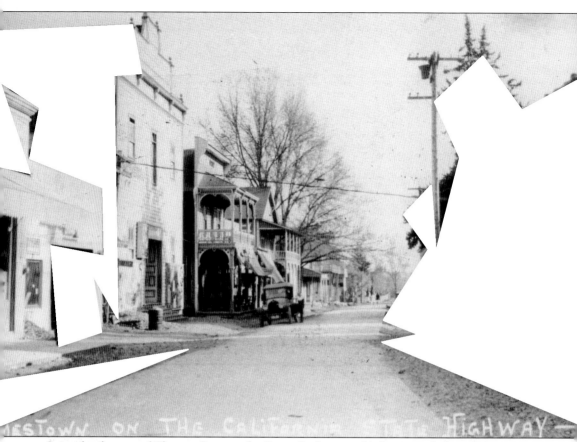

ESTOWN ON THE CALIFORNIA STATE HIGHWAY

Several miles east of Chinese Station, the Sierra Railway reached its intended eastern terminus, Jamestown. A sleepy Gold Rush village in 1897, when the Sierra Railway came to town, Jamestown's Victorian architecture belied the fact that it had fallen on hard times. Like in so many Mother Lode towns, Jamestown's success was in the past, and the citizens of the town were rightfully concerned about what the 20th century might bring. The old Main Street of Jamestown was about a mile from where the Sierra Railway would build its shops. The old town spoke of a dying Victorian splendor, which worried the local citizenry. The railroad spoke to a more prosperous future; for that reason, the people of Jamestown were always good friends to the Sierra Railway. (Tuolumne County Historical Society.)

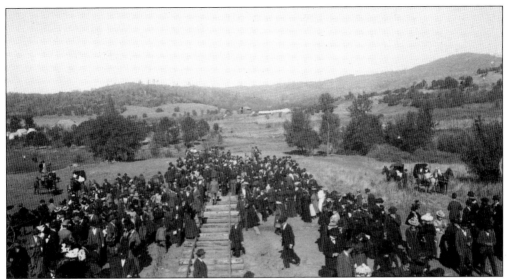

The arrival of the railroad promised a renewed prosperity for Jamestown and for all of Tuolumne County. Residents of the county were initially overjoyed to welcome the line to the area, with the construction jobs and future development that it promised. The citizens of Tuolumne County helped the Sierra Railway enact a driving of the golden spike on November 8, 1897, to commemorate completion of the line to Jamestown. The ceremony was a miniature version of the great event in 1869 at Promontory Point, Utah. (California State Railroad Museum.)

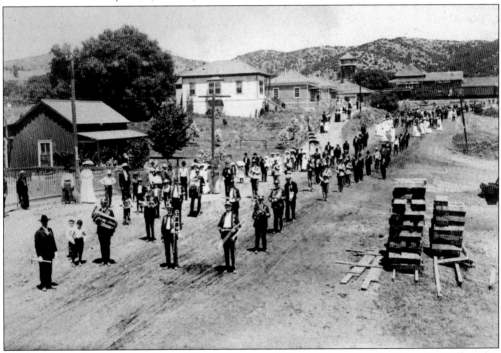

This photograph shows another celebratory event in Jamestown, near the Hotel Nevills. This scene is sometimes interpreted as being a celebration of the opening of the line. More likely, this celebration is unrelated to the opening of the railroad; perhaps it is a Fourth of July parade. (California State Railroad Museum.)

Junction Train – Oakdale Cal. – Mar 1st 189

There was cause for celebration on the Oakdale end of the line, as well. The opening of the Sierra Railway transformed Oakdale's role from an insignificant stop on a Southern Pacific branch to the gateway to the Mother Lode. Here, Sierra locomotive No. 2 leaves the station in Oakdale, pulling a long passenger train to Jamestown. This March 1898 photograph is the oldest known image of a Sierra Railway locomotive other than Sierra No. 3. Sierra No. 2 was used during construction and scrapped shortly after, but its fancy bell was later used on passenger locomotive No. 6 and finally saved. Today, it is at the Tuolumne County Historical Society. This is a rare view, indeed. (Tuolumne County Historical Society.)

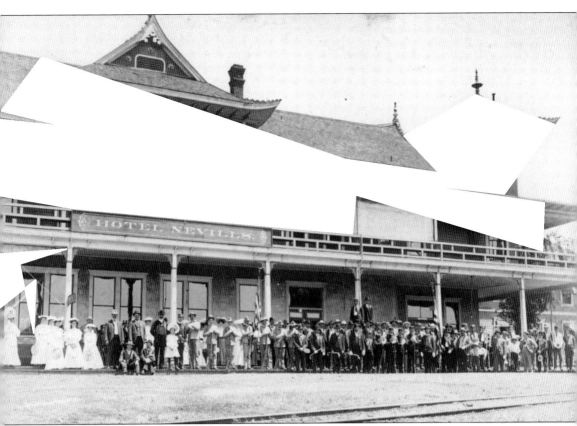

The land for the Jamestown station and shops was located about a half-mile south of historic downtown Jamestown. The Sierra Railway principals saw an opportunity to profit from the distance between the shops and the downtown area. Even before the station was built, the Sierra Railway investors bought much of the land between the two and laid it out as a subdivision. The Sierra Railway developers also worked with a local investor, Capt. A.W. Nevills, to build a hotel at the site of the station and shops. Nevills owned the nearby Rawhide Mine. Although the hotel bore his name, he quickly sold his interest in it during a disagreement with Bullock, Poniatowski, and Crocker. The grand Hotel Nevills was located just east of the Sierra Railway shops. The hotel was designed by a British architect, George Rushforth, who was living in Stockton at the time. (California State Railroad Museum.)

Neither architect George Rushforth nor investor Thomas Bullock explained why they chose to design the Hotel Nevills building with a decidedly Japanese flair. This style extended to the station in Jamestown, as well as to the stations in Sonora and Tuolumne City. One possible explanation for the Japanese motif was the popularity of the Japanese exhibit at the World's Columbian Exposition in Chicago in 1893, built only a few years before the Hotel Nevills. The grand hotel reflected the great optimism and flamboyance of the Sierra Railway leadership in 1897. Unfortunately, the hotel burned down in 1915 and was never rebuilt, a fact that reflects the pragmatism that took hold of the railroad in the second decade of the 20th century. Here, Pickering Lumber Company No. 12 idles in front of the hotel in 1915, just before it burned down. (California State Railroad Museum.)

Three

BUILDING THE SHOPS AND YARDS IN JAMESTOWN

The Sierra Railway chose to make Jamestown its center of operations in 1897, and, as originally planned, it remained the eastern terminus for the next five years. Although it was a small short line, the Sierra Railway was nonetheless a complex operation requiring many different pieces. The principal requirements were as follows: a station to handle offices and passenger services, a freight shed to handle bulk freight, a roundhouse and turntable to provide space to work on locomotives and cars, and yards with enough trackage to allow trains to be assembled and routed to their destinations. All of this was built in an area of about 26 acres in the yards and shops of Jamestown.

The various buildings in the Jamestown Shops were erected in stages, as needed, between 1897 and the 1920s. Not all of these buildings still exist. Fire was a terrible scourge in an industrial facility built around fire and steam. The buildings that no longer exist were, with rare exception, destroyed by fire. The 26 buildings that still exist today make up one of the most interesting and intact steam-era railroad shops anywhere in the United States.

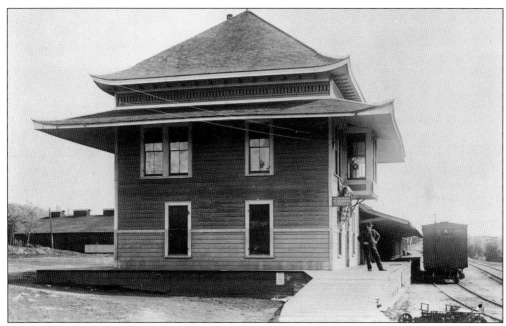

The first passenger depot at Jamestown was actually in the lobby of the Hotel Nevills. Next to the hotel was a two-story structure housing the general office (upstairs) and the freight office (downstairs). The general office building was a smaller version of the Japanese-inspired Hotel Nevills and was built by the same architect, George Rushforth. One of the great tragedies in the history of the Sierra Railway is that all of the Japanese-inspired buildings the railway erected have burned down or been demolished. There were once four of these, including the general office and the Hotel Nevills in Jamestown, a handsome station in Sonora, and another small station in Tuolumne. (California State Railroad Museum.)

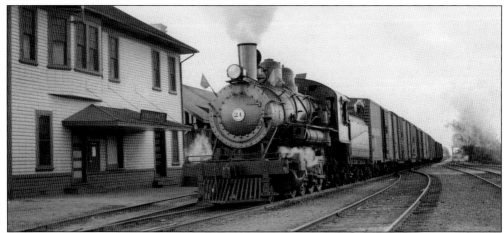

The general office in Jamestown unfortunately burned to the ground in 1913. The railway built a new station almost immediately at the original location. It was slightly larger than the first, but it lacked the architectural pizazz of the 1897 building. After the Hotel Nevills burned down in 1915, the passenger depot and express offices were moved into this building, making it the (new) passenger depot. The building (pictured) was in use from 1913 until 1978, when it, too, burned to the ground—the victim of a suspected arsonist. This photograph shows the second-generation general office/depot with Sierra No. 24 in front. (California State Railroad Museum.)

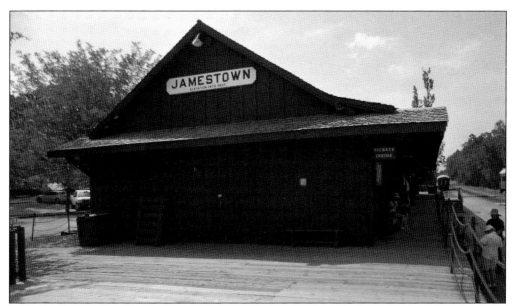

Jamestown needed a substantial freight shed. The first business model called for the Sierra Railway to go no farther east than Jamestown for the first five years, allowing local freight income to pay down the debt of building the line. However, this model was abandoned less than a year into operation of the line. In the original business model, however, a sturdy freight shed was a major asset capable of accepting freight brought to the site by wagon and taken to Oakdale by rail. The freight shed was built in 1897 and is still in use today, as shown in this recent picture. It is at the heart of the interpretive program at Railtown 1897 State Historic Park. (Photograph by Stephen D. Mikesell.)

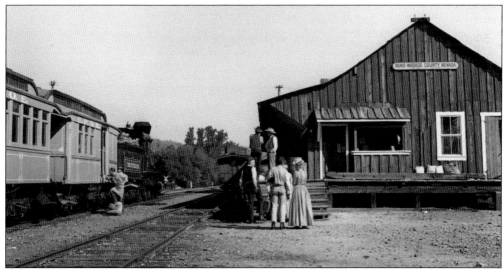

Although the Jamestown freight shed lost importance after the line extended to Sonora and Angels Camp, the building has survived and has been in use for a century. Since the 1920s, the building has been featured in dozens of movies and television shows, as shown in this 1962 still from the television series *Death Valley Days*. In movies and television shows, the freight shed was often treated as if it were a passenger depot. This was not its role, historically, but it currently serves as a passenger depot in the state park. (Tuolumne County Museum.)

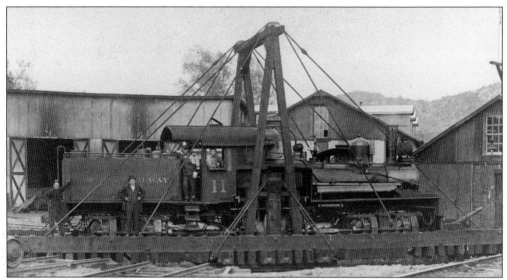

Early on, the designers of the Sierra Railway elected to use a turntable and roundhouse for repairing its locomotives and cars. By the late 1890s, when the Jamestown Shops were built, the turntable-roundhouse arrangement was generally recognized as the most efficient way of handling car repair, particularly locomotive repair. The first turntable at Jamestown was installed about 1900 and was an A-frame, or "Armstrong," design (it was moved manually, requiring a strong arm). This photograph is one of the few that shows the original turntable. The locomotive is Sierra No. 11, a gear-driven Shay built in 1902 for use on the Angels Branch line. No. 11 was built by the Lima Locomotive Works of Lima, Ohio. (California State Railroad Museum.)

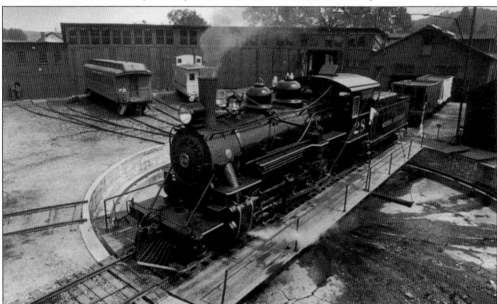

In 1922, the original Armstrong turntable was replaced with a newer model purchased used from the Great Northern Railroad. Here, locomotive No. 28 is shown on the 1922 turntable. No. 28, built in 1922 by the Baldwin Locomotive Works of Philadelphia, is still owned by Railtown 1897. It is currently being restored for another century or so of service. (California State Railroad Museum.)

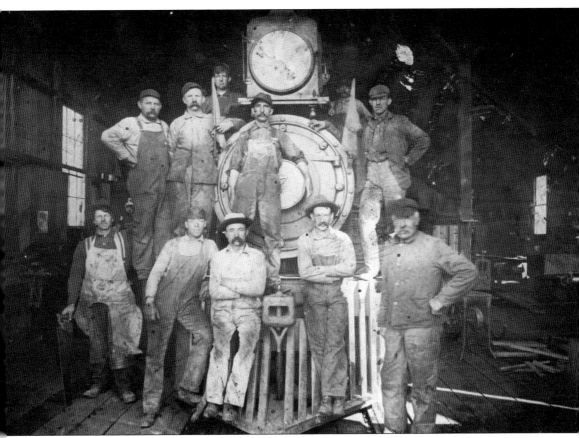

The roundhouse at the Jamestown Shops went through various iterations, achieving its current appearance in the mid-1920s. At first, there was no roundhouse—only a single, two-stall structure called the "Engine House," indicating its role in the repair of locomotives. This building was constructed in 1897 and is still in place and still in use, although now it is called the "Machine Shop." Today, it houses the most sophisticated and important machinery at the shops and is treasured for the extremely rare belt-driven drills, punches, and other equipment there, which are still being used to keep the line running. This is a rare portrait of mechanics at work inside the machine shop when it was still the engine house. The locomotive is Sierra No. 7, a 4-4-0 Baldwin purchased by the Northern Pacific Railroad in 1882 and acquired by the Sierra Railway in 1889. It no longer exists. (California State Railroad Museum.)

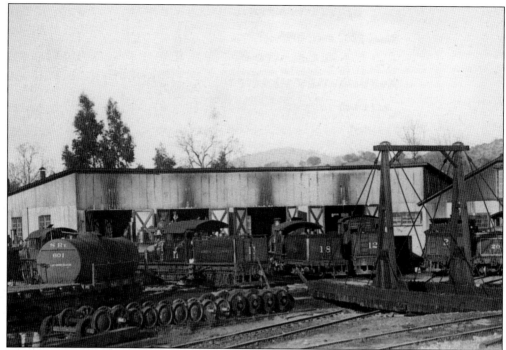

Around 1900, the Sierra Railway installed a four-stall roundhouse just to the left side (west) of the machine shop. The first turntable was installed at the same time. This is a rare photograph of this short-lived structure; it burned to the ground in October 1910. Fortunately, the machine shop survived the blaze. (California State Railroad Museum.)

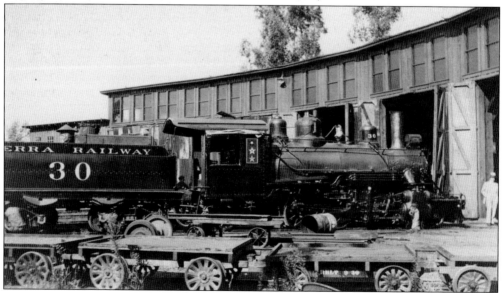

Immediately following the October 1910 fire, the Sierra Railway built a four-stall roundhouse on the site of the 1900 roundhouse, which also had four stalls. The roundhouse expanded in 1922—adding two additional stalls—as part of the same improvement that included the installation of a new turntable. This photograph of the expanded six-stall roundhouse was probably taken shortly after the additional stalls had been constructed. (California State Railroad Museum.)

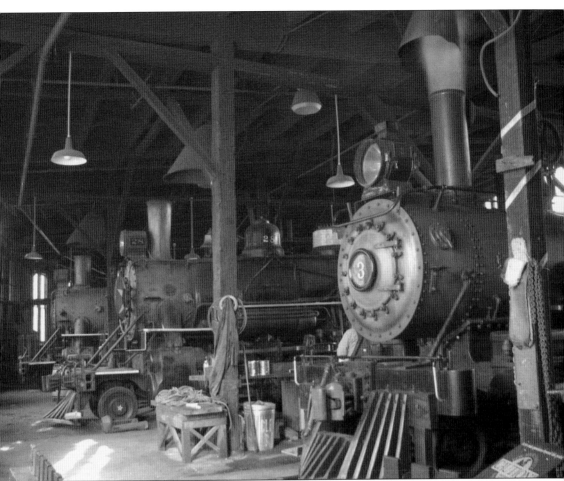

The roundhouse is still very much in use. California State Parks relies upon the facility, with its pits and overhead cranes, to repair steam locomotives and other pieces of historic rolling stock. In this modern photograph, Sierra No. 3 and the other steam locomotives at Railtown 1897 are parked side-by-side. In addition to being a garage for the locomotives, the roundhouse is used to repair any other equipment at the park. As noted in chapter five, Sierra No. 28, one of the key assets at Railtown 1897, was undergoing a major rehabilitation at the time of this writing. (California State Railroad Museum.)

In the early years of the 20th century, the Sierra Railway began to expand rapidly, with major lines leading to the towns of Sonora and Tuolumne in Tuolumne County and to Angels Camp in Calaveras County. This expansion necessitated the creation of a complex yard at Jamestown to accommodate differing mixes of traffic. Shown here is a general overview of the yards. Probably taken in the late 1940s or early 1950s, the photograph shows the roundhouse (left) and the Sonora main line (right). Behind the photographer was the main line that led from Oakdale to Jamestown in the early 1900s. Another line was extended to Angels Camp and was called the Angels Branch. (California State Railroad Museum.)

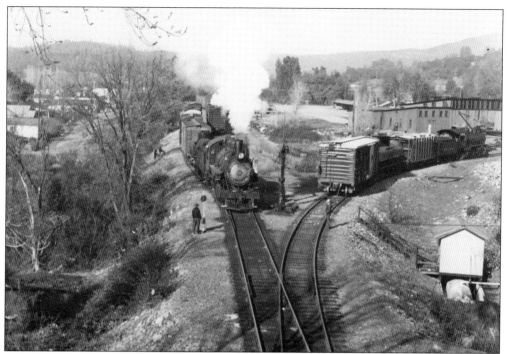

This 1950s photograph shows where the main line/Jamestown depot lead meets the lead to the roundhouse pictured on the previous page. In railroad terms, a lead is a short length of track used to access a specific spot, such as a roundhouse. The depot and freight shed behind the forward-facing locomotive are obscured by the steam from the engine. (California State Railroad Museum.)

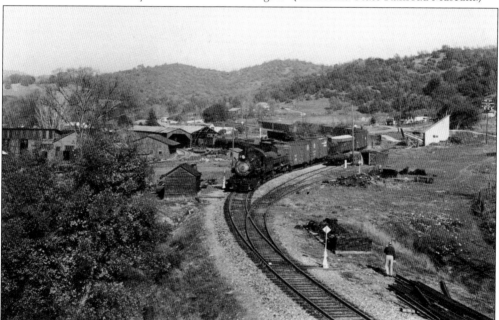

This photograph shows all the major tracks within the Jamestown yard. The track at left is the Jamestown depot lead, which led to the Angels Branch. The track in the center led to the roundhouse area. (California State Railroad Museum.)

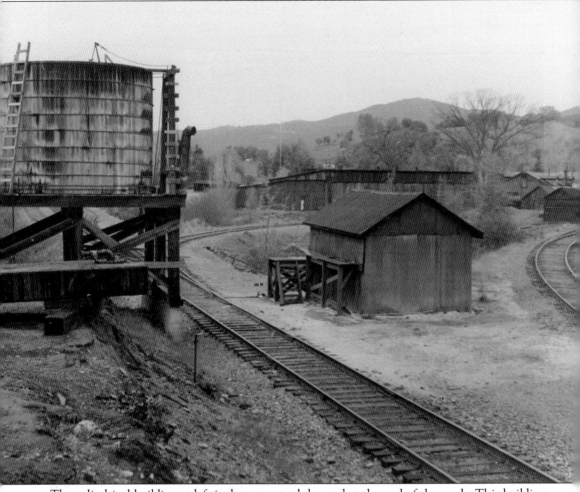

The cylindrical building at left is the water tank located at the end of the yards. This building became famous in the 1960s, when it was used as the outdoor bath for the female stars on the television show *Petticoat Junction*. The building at center is a steam boiler used to heat the heavily viscous fuel oil in order to make it move through pipes to the waiting locomotives. The boiler house was later converted to the sand house to provide dry sand to give locomotives traction on wet, slippery rails. The roundhouse is clearly visible in the background. (California State Railroad Museum.)

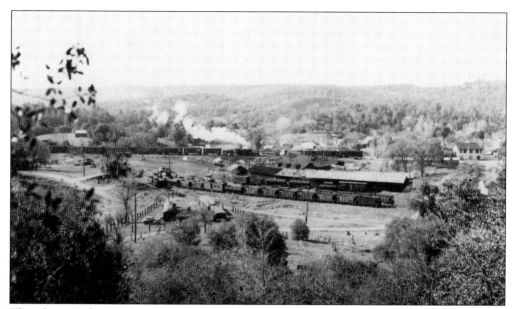

This photograph provides an overview of the entire yard as it existed in the late 1940s. Most of the structures shown here still exist and are in use today. (California State Railroad Museum.)

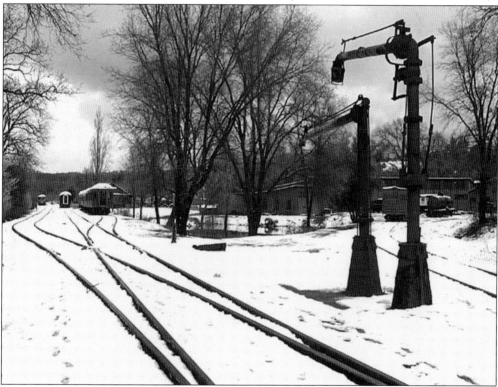

This photograph offers a unique—or at least extremely rare—view of the yards in snow, something that occurs perhaps once a decade in Jamestown. The two devices at right are water and fuel-oil hoses. They are located at the head of the yards, where any locomotive could access them before heading to Sonora, Angels Camp, or the roundhouse. (California State Railroad Museum.)

Likely taken in the 1950s, this photograph shows the roundhouse at Jamestown, perhaps just after the Sierra Railroad had been dieselized and the yards and shops were put into a holding pattern. The interest of the motion-picture industry and the zealous enthusiasm of railfans for this authentic piece of railroad history would help the Sierra avoid the fate of most steam railroad operations. While Jamestown is still a remote and somewhat sleepy town, the sound of steam engines and whistles draws visitors to the Railtown 1897 state park there, making the area even busier today than it is in this image. (California State Railroad Museum.)

Four

Expansion to Sonora, Angels Camp, and Yosemite

Although the Sierra Railway's original business plan emphasized a five-year hiatus in construction once the line reached Jamestown, the lure of business opportunities to the east in Tuolumne and Calaveras Counties, coupled with disappointing results at Jamestown, drove the Sierra Railway team to build east, first to Sonora and Tuolumne, and then to Angels Camp. Sonora and Tuolumne were much closer than Jamestown to the vast timber stands that were central to the Sierra Railway's future and remain the primary reason it survives today. Angels Camp was a center for hard-rock gold mining, and the branch served several other important mines along the way. The mountains above Sonora had promising sites for water development. These three industries anchored the local economy in the first half of the 20th century.

Expansion to Sonora was especially attractive, because there were multiple industries there just waiting to be served by a railroad. Sonora was one of the largest Gold Rush towns in the middle of the 19th century. Like most such towns, however, it had fallen into inactivity in the late 19th century, as placer mining precipitously declined. In 1900, however, Sonora was beginning to come to life again due to gold mining, lumber, and a marble industry.

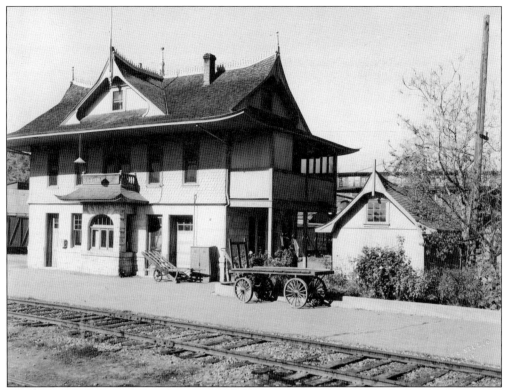

The Sierra Railway built a station in Sonora that repeated the Japanese motif of the general offices and Hotel Nevills in Jamestown. This grand structure, surely one of the prettiest and most unusual railway stations in California, was destroyed by fire in the 1950s. (California State Railroad Museum.)

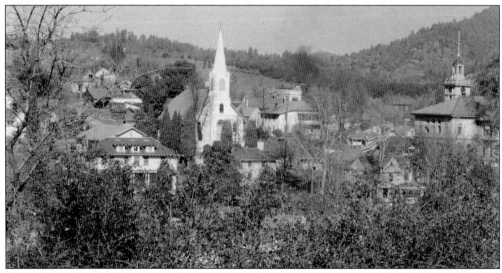

Throughout the decades, Sonora has been one of the prettiest towns in the California Mother Lode. This image was captured by a photographer for the Historic American Buildings Survey in 1936, during the era when the Sierra Railway was offering regular passenger and freight service to the town. (Library of Congress.)

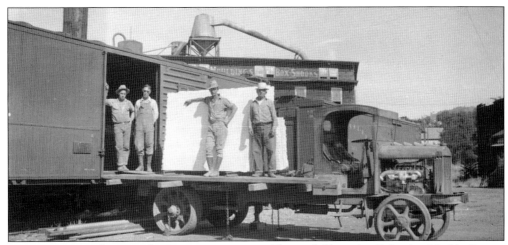

One attractive industry in the Sonora area was marble, available at the Columbia Marble Quarry located a few miles outside of Sonora. The principals of the Sierra Railway invested in the Columbia quarry and many other industries in Tuolumne County. This photograph, taken at the Sonora depot in the 1920s, shows a crew unloading a huge slab of Columbia marble brought to the freight yard by truck. The truck-railroad interface was typical of much of the freight business for the Sierra Railway beginning in the early 20th century. (California State Railroad Museum.)

The tiny town of Columbia, about two miles from Sonora, was closely linked to the Sierra Railway through the movie business. Studios were attracted to the Sierra Railway for shooting Westerns because of the authentic feel of the steam equipment and the untouched adjoining landscape. Filmmakers were equally attracted to Columbia, a great city during the Gold Rush that had become almost a ghost town in the early decades of the 20th century. Makers of Western movies often used Columbia and the Sierra Railway in the same film. Perhaps the best-known example was the hit *High Noon*, which used the equipment of the Sierra Railway for its railroad scenes and the old buildings of Columbia for its famous gunfight. This photograph shows a building in Columbia in 1936, about 15 years before *High Noon* was filmed. (Library of Congress.)

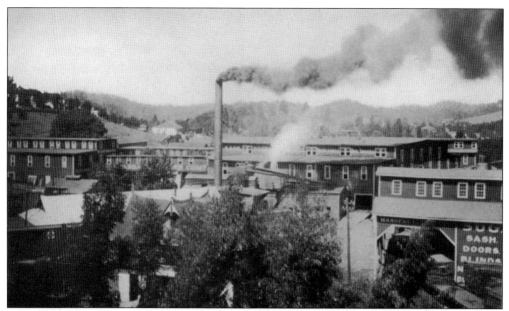

After 1900, the most important industry in Tuolumne County was lumber, not mining. The owners of the Sierra Railway did not passively wait for a lumber industry to develop. Rather, they organized a series of lumber companies: first, the West Side Lumber & Flume Company, under the leadership of Crocker, Poniatowski, and Bullock; then the Standard Lumber Company, with Bullock and other partners, which years later would absorb the old West Side operation. Both the West Side and Standard companies developed their own railroad systems to serve the timberland they owned. The West Side Lumber rail lines were narrow-gauge, and the Standard Lumber lines were standard-gauge. This postcard from the 1910s shows the huge operation of the Standard company box factory and its sash and door factory in Sonora, which was served by the Sierra Railway. (Tuolumne County Historical Society.)

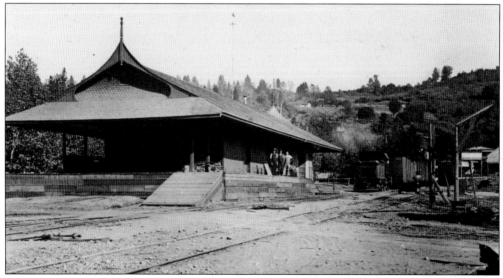

The Sierra Railway leaders erected a station and other buildings, including a hotel, in the town of Tuolumne, chiefly to service the nearby West Side Lumber Company operations. The Tuolumne Station is pictured here around 1923. (California State Railroad Museum.)

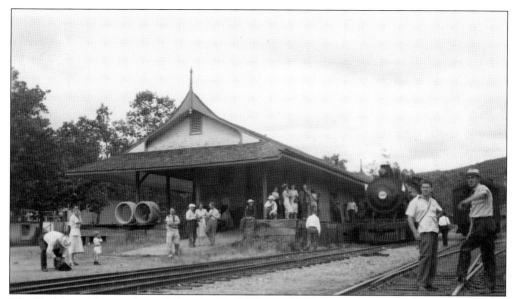

The Tuolumne Station hosted this excursion run in 1947. Railfans romanticized the steam era and flocked to the Sierra Railroad in the period immediately following World War II. The Sierra Railway station at Tuolumne was the last of many buildings to be constructed in a Japanese motif. The various stations served freight and passenger traffic as dictated by the conditions of the particular stop. Lamentably, none of the first-generation Sierra Railway, Rushforth-designed, Japanese-influenced buildings still exist, except in historic photographs located in various local archives and reproduced in this book. (California State Railroad Museum.)

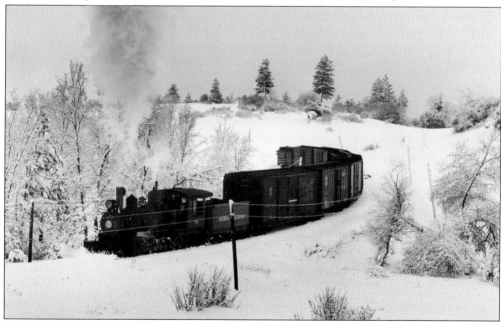

The Sierra Railway was generally below the snow country of the Sierra Nevada. Here, locomotive No. 18 pulls a line of boxcars though the snow above Sonora—a rare operation through a snow-covered landscape. This photograph was taken on February 5, 1949, by well-known railfan and photographer Al Rose. (California State Railroad Museum.)

Sierra locomotive No. 18, with combination passenger-baggage car No. 5 as caboose, waits in the snow at the Tuolumne Station in February 1949. Sierra No. 18 was a 2-8-0 locomotive purchased new by the Sierra Railway in 1906. Built by the Baldwin Locomotive Works, the engine is no longer in Jamestown, but it still exists in Oregon. Car No. 5 still exists and is sometimes used in Railtown 1897 excursions and in the filming of movies. The non-locomotive rolling stock within the Railtown 1897 collection is among the most interesting of any steam-era collections in the United States. (California State Railroad Museum.)

Inspired by their success on the Sonora line, the leaders of the Sierra Railway decided to expand through the canyon of the Stanislaus River to the gold mines of Calaveras County. This branch, called the Angels Branch because it terminated in Angels Camp, was by far the most daring effort by the company. It went down a steep canyon that could be traversed only via switchbacks on both sides of the river and curves too sharp for conventional locomotives and passenger cars. The branch was the first part of the Sierra Railway to be abandoned during the Great Depression in the 1930s. One of the most dramatic aspects of the Angels Branch was the crossing of the Stanislaus River near the town of Melones. Here, Sierra No. 30 locomotive pulls a mixed freight and passenger train. No. 30 was purchased from the Baldwin Locomotive Works specifically to serve this line, chiefly because it was slightly shorter than any other engines on the Sierra line. The railroad bridge, a Pratt deck truss, connected to a long timber trestle on the Calaveras County side of the river. (California State Railroad Museum.)

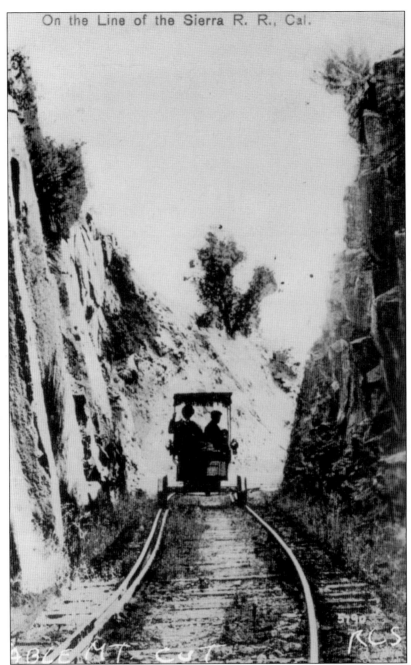

On the Line of the Sierra R. R., Cal.

The Angels Branch veered from the original Sierra Railway main line in Jamestown, turning east to Table Mountain. The first piece of impressive engineering for this line was a huge cut at Table Mountain. The mountain, a mesa created by lava flows down the Stanislaus River, is just south of Jamestown and is visible from any part of town. The Sierra Railway dealt with the imposing formation by cutting a path straight through it. The vehicle shown here is a gasoline-powered "speeder," or track car. These small cars were used to inspect track and structures without the expense of moving a locomotive. Railtown 1897 includes an exceptional collection of speeders. (California State Railroad Museum.)

The route involved a switchback on the Tuolumne County side of the canyon, near Tuttletown. This switchback required the locomotive to push the train backward until it got to switchback No. 2, where the train could resume forward progress down the canyon and across the Stanislaus River on a metal deck truss bridge. It then proceeded to the town of Melones, where it switched twice to go up the canyon to Angels Camp. Switchbacks, although not unprecedented, represented the most distinctive aspects of track design on the Angels Branch. Pairs of switchbacks were located on both sides of the river. A locomotive would approach the first switchback in forward gear and would leave in reverse, continuing thusly until it reached the second part of the pair of switchbacks, which it would leave in the forward direction. Shown here is Sierra locomotive No. 24 with combination car No. 5 as caboose. In the 1940s and 1950s, locomotive No. 24 was the standard power for the Jamestown-to-Tuolumne freight trains. (California State Railroad Museum.)

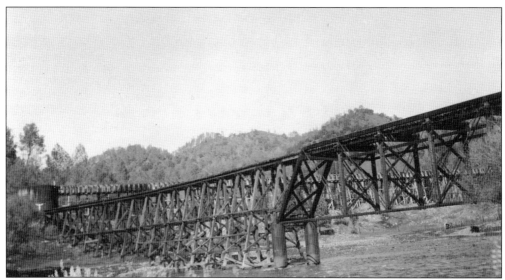

Trains crossed the Stanislaus River via a steel deck truss span that was linked to a long, winding trestle that kept the railroad out of the floodplain. From an engineering standpoint, the long trestle was at least as important as the river crossing. In this photograph, a water flume is shown crossing the railroad line. (California State Railroad Museum.)

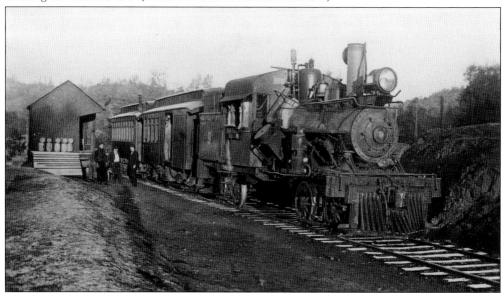

The alignment of the Angels Branch was so twisty that it required different equipment designed to maneuver on the curvy track, including shorter conventional locomotives, like Sierra No. 30, or earlier geared locomotives (Shays and Heislers) and passenger cars that were shorter than usual. The station at Carson Hill is shown here with Heisler No. 9, a geared locomotive, with short chassis cars Sierra No. 5 and No. 6. The Heisler locomotive was scrapped in 1947. Heisler locomotives were manufactured by the Heisler Locomotive Works in Erie, Pennsylvania, and built around a design patented by Charles Heisler in 1892. Heislers are easily recognizable by the angled and opposing pistons, called a V-twin design—not unlike a V-8 design for automobile engines. Carson Hill was a monumentally large, hard-rock gold mine at the top of the canyon above the Stanislaus River. (California State Railroad Museum.)

The Angels Branch did not warrant the architectural bravado of the Sonora line. Stations were few and strictly utilitarian in design, including this station at Carson Hill, which is pictured sometime after the railroad was abandoned and its track removed in the mid-1930s. (California State Railroad Museum.)

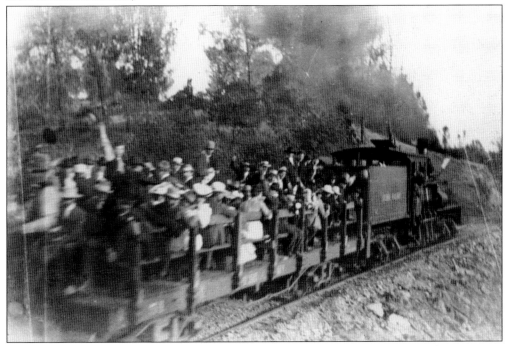

From the outset, the Angels Branch was as much a passenger line as it was a freight operation. The people of Tuolumne and Calaveras Counties were neighbors in terms of strict proximity but strangers because the trip down the Stanislaus River Canyon was so arduous on horseback or in a wagon. The Angels Branch of the Sierra Railway was hardly rapid transit, with its switchbacks and slow curves, but it was wonderfully fast and convenient compared to what came before. This is a rare picture of an excursion on the Angels Branch in 1906, a few years after the line was completed in 1902. (Tuolumne County Historical Society.)

Angels Branch, the most dramatic technological achievement of the Sierra Railway, was also its biggest financial failure. During the lean years of the Great Depression, the branch was the first piece of track to be abandoned. For about 30 years, however, this little line connected a series of very small communities on both sides of the Stanislaus River, including Tuttletown on the Tuolumne side. This stone building is Swerer's Store in Tuttletown. The structure, with metal shutters installed for fire prevention and security, caught the attention of a photographer from the Historic American Buildings Survey on April 5, 1934. (Library of Congress.)

Although it was a tiny town in the 19th century and even tinier today, Tuttletown is an important site in American literary history. It was here that Mark Twain wrote his famous short story "The Celebrated Jumping Frog of Calaveras County." Twain fled San Francisco because of legal problems and holed up in a cabin owned by his friend Jim Gillis in Tuttletown. At some point, Twain ventured into Angels Camp and heard the tall tale of the jumping frog. He wrote the story while living in Gillis's cabin and later returned to San Francisco to get it published. That was the beginning of Twain's storied career. The cabin, shown here in 1936, has since been restored at least twice and is a popular destination for literary historians. (Library of Congress.)

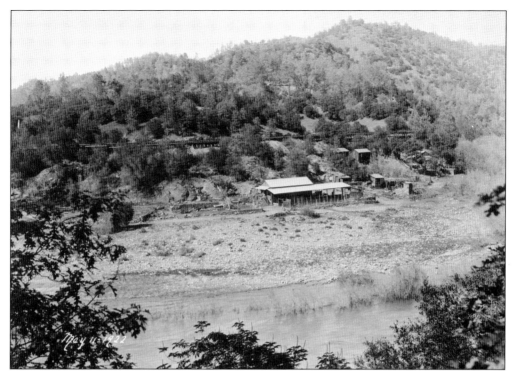

Another tiny town along the Angels Branch line was Melones, located at the river crossing on the Calaveras County side. It grew into a large hard-rock mining site shortly after the Sierra built through the area, only to disappear as a settlement before it was flooded by a reservoir in the 1980s. This photograph was taken in 1922. (Library of Congress.)

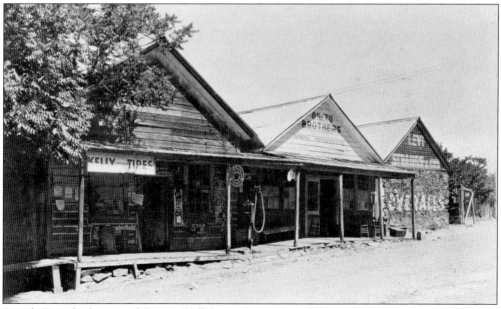

Angels Branch also served Carson Hill, located atop the hill beyond Melones. Carson Hill grew into a huge mining capital in the 1930s, but it was still a sleepy burg when the Sierra built there in 1902. (Library of Congress.)

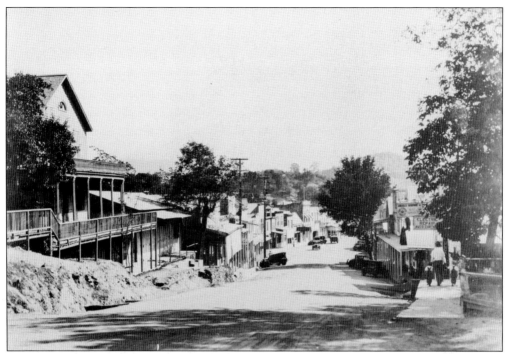

The Angels Branch terminus was in Angels Camp, considered a major stop along what is now Highway 49. Local boosters called the route the Golden Chain Highway, as it linked the many Gold Rush towns in the Sierra Nevada foothills. Angels Camp was a very small town when this photograph was taken in the mid-1930s and, in many respects, it is a small town today. (Library of Congress.)

A prominent building in Angels Camp was (and still is) the Angels Hotel. It was in this hotel that Mark Twain first heard the urban legend that he would retell in his story "The Celebrated Jumping Frog of Calaveras County." The hotel, shown here in 1935, appeared much this way when Twain visited, and it looks much the same today. (Library of Congress.)

A longstanding dream of Sierra Railway co-owner Thomas Bullock was to build a branch line from the Sierra Railway to Yosemite. A known wagon route, the Big Oak Flat Road, extended to near the edge of the valley. That alignment veered off from the Sierra Railway near Chinese Station. All that was needed, Bullock figured, was to lay track along the same alignment and tap into the tourist trade to Yosemite National Park—and all the timber along the way. This dream would not materialize during Bullock's lifetime. He began building a narrow-gauge Yosemite Short Line along the Big Oak Flat alignment in 1906, but the 1906 earthquake in San Francisco and the financial panic of 1907 froze investment in all speculative ventures, including the Yosemite Short Line. Only a few miles were laid on this line before construction was halted. Almost nothing remains today to memorialize this short-lived venture. Railtown 1897 does, however, retain a single hulk of a narrow-gauge boxcar, which the park protects under a freestanding roof (pictured), in recognition of the rarity of this resource. (Photograph by Stephen D. Mikesell.)

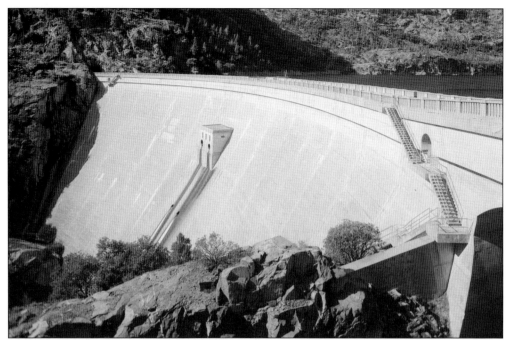

In time, the City of San Francisco completed Bullock's dream and built a standard-gauge line along the Big Oak Flat alignment to allow the city to build a huge water-supply dam within Yosemite National Park. This line, called the Hetch Hetchy Railroad, was owned by the City of San Francisco. The Sierra Railway expanded a great deal in order to supply the Hetch Hetchy Railroad with concrete, gravel, and other supplies. In the 1930s, when San Francisco chose to raise the dam, the Sierra Railroad took control of the Hetch Hetchy and directly transported material needed for the job. In many respects, the Hetch Hetchy Railroad and O'Shaughnessy Dam were a fulfillment of Thomas Bullock's dream of building a line from the Sierra Railroad into Yosemite National Park. The O'Shaughnessy Dam (pictured) impounds Hetch Hetchy Reservoir, which provides drinking water to one of America's great metropolises. (Library of Congress.)

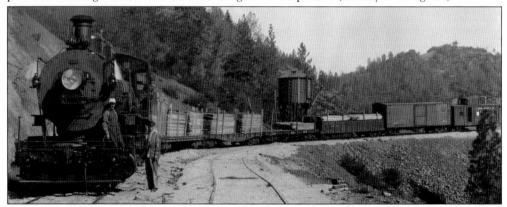

Today, very little remains of this short line, which required great engineering feats as it was built through the wilderness. Small stations were built along the line chiefly to service the locomotives. This photograph shows a water tank and siding at the stop called Rattlesnake. Almost nothing remains of that effort, because the line was never intended to be a long-term enterprise; it was constructed to allow the city to build a dam. The Hetch Hetchy Railroad was removed in 1949. (California State Railroad Museum.)

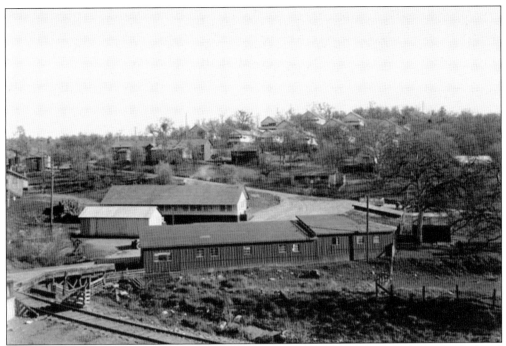

The City of San Francisco built a small community at the junction of the Hetch Hetchy Railroad and the Sierra Railway called, appropriately, Hetch Hetchy Junction. The community included basic necessities that might be needed for the families involved in building the railroad and the dam at Hetch Hetchy. The small town does not exist today. (California State Library.)

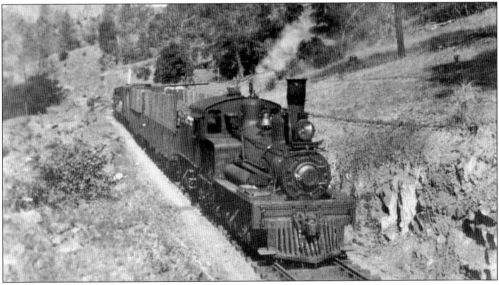

Although the Hetch Hetchy Railroad was the property of San Francisco, it relied on equipment of the Sierra Railway to build both the line and the dam at its terminus. In this 1917 photograph, Sierra locomotive No. 11 is shown in service on the Hetch Hetchy line near Moccasin. Located south of Chinese Station, Moccasin is still used by San Francisco as a power-generation facility and as headquarters for the maintenance of the water and power lines that stretch from Yosemite to San Francisco. (Tuolumne County Historical Society.)

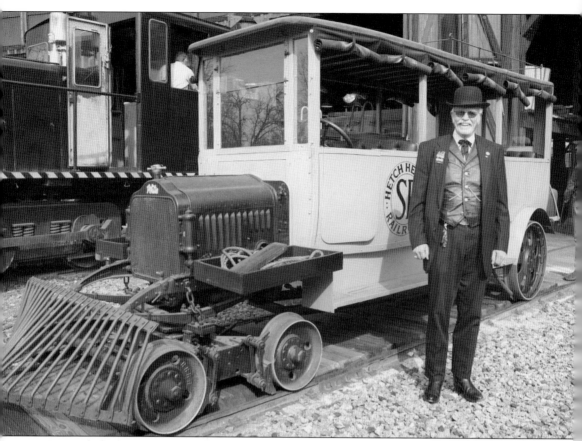

Some of what remains of the Hetch Hetchy Railroad lives at the Railtown 1897 State Historic Park. In the fullness of time, the modern state park came into possession of several interesting relics from the San Francisco operation. Of these, none is more interesting than Sierra No. 19 (old Hetch Hetchy 19), a gasoline-powered railcar that took dignitaries to the dam site. The vehicle did double duty as an ambulance when accidents occurred, as often happened during railroad and dam-building work. Hetch Hetchy 19 is one of the most important parts of the Railtown 1897 collections and one of the best-known railcars in the United States. Here, volunteer John Rand stands beside Hetch Hetchy 19. Rand is playing the part of Thomas S. Bullock, who would have loved to have seen what became of his dream of a railroad into Yosemite National Park. (California State Railroad Museum.)

Five

LOCOMOTIVES

In 1955, the Sierra Railroad (which was renamed in the 1930s during a bankruptcy reorganization) made the change from steam to diesel-electric locomotives. The process, commonly called dieselization, signaled the end for most old steam equipment, as well as the yards and shops that supported them. However, by the 1950s, the Sierra Railroad had established a lucrative arrangement with the film industry; the railroad would supply period rolling stock for use in films, most of which were Westerns.

As a result of this accident of history, the remnants of the Jamestown Shops, now operated as Railtown 1897 State Historic Park, showcases a collection of some of the most widely seen steam locomotives in the world. These locomotives are in a constant state of repair partly to serve the public via excursion lines and partly to service a continued business in the film industry. By far the most famous of the Sierra locomotives is No. 3, a 4-6-0 built by the Rogers Locomotive Works in 1891 and purchased by Thomas Bullock for use on his ill-fated Prescott & Arizona Central (P&AC) Railway. When the P&AC failed, Bullock brought Sierra No. 3 to be one of his first locomotives on the Sierra Railway.

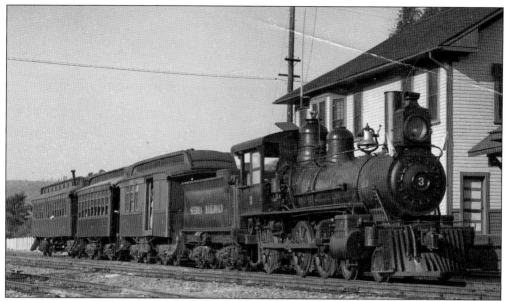

Sierra No. 3 is still in use, carrying excursions for the California State Park at Railtown 1897. It is shown here at the second general offices building at Jamestown, pulling a small passenger train. The date of this photograph is not known. (California State Railroad Museum.)

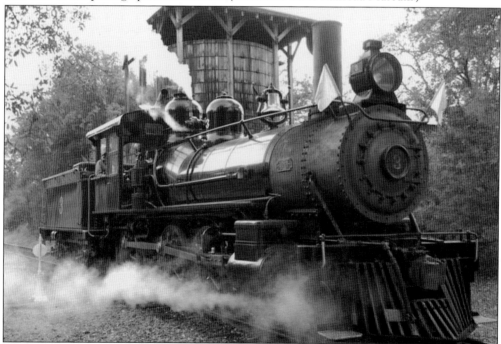

Sierra No. 3 is widely believed to be among the most photographed—if not the most photographed—steam engine operating in the United States. The movie business, of course, accounts for most of its fame. It cannot be denied, however, that No. 3 is a good-looking engine that fits into its setting in a way that makes for photographic magic. That setting extends all along the railroad line, which No. 3 has served for more than a century, from the open plains near Cooperstown to the better-known yards at Jamestown (pictured). (California State Railroad Museum.)

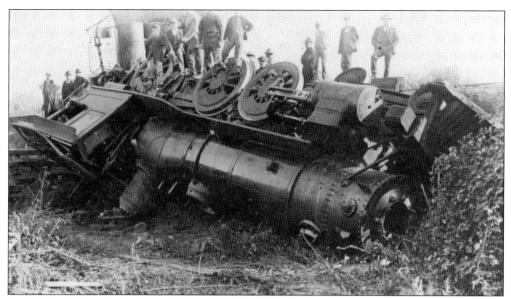

As with the Sierra Railway, No. 3 was not built as a movie star. It was a workhorse throughout the early 20th century, pulling freight trains as well as passenger cars. Life was tough in an industrial operation like the Sierra Railway, and Sierra No. 3 suffered its share of mishaps. The worst of these occurred on November 25, 1918, when the locomotive toppled in a derailment, destroying the original 1891 wooden cab. It was replaced in early 1919 with a secondhand Southern Pacific steel cab, which is part of its character today. (California State Railroad Museum.)

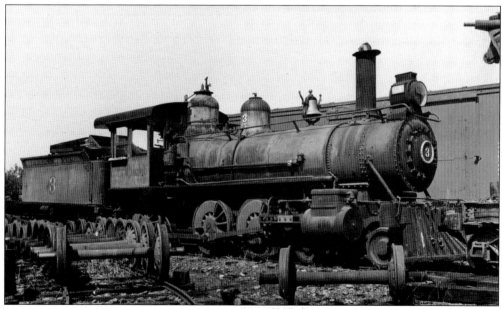

No. 3 was used extensively in the early years of filmmaking on the Sierra Railway. In 1932, however, the locomotive—then more than 40 years old—was taken out of service and parked at the Jamestown Shops. Here, No. 3 is parked idly and ignominiously in the Jamestown yard next to unused trucks and miscellaneous spare parts. (California State Railroad Museum.)

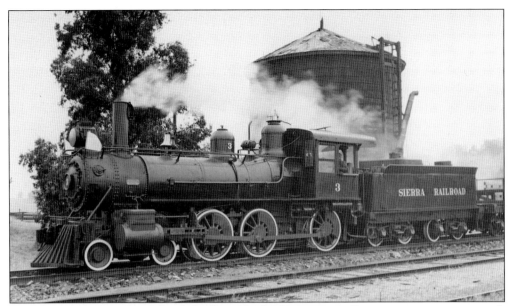

In 1947, the Sierra Railroad decided to bring back No. 3, principally in response to movie work and to satisfy the growing demand of railfans, who began to flock to the Jamestown steam yard as early as the late 1930s. No. 3, given extensive repair and restoration inside the Jamestown Shops, emerged as a glamorous movie star—her best roles were played after the 1947–1948 restoration, and it remains a movie star today. The locomotive almost never carries the Sierra Railroad emblem in its movie roles, however, as it is repainted to match the particular setting for each film or television show. (California State Railroad Museum.)

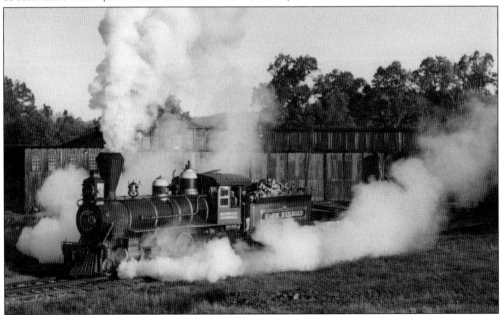

Sierra No. 3 was as much a hit in television work as it was in the movies, making major appearances on the small screen in *Petticoat Junction*, *Bonanza*, *Death Valley Days*, and *Rawhide*. Here, it is steaming and showing off in its role as the "Hooterville Cannonball" in *Petticoat Junction*. (California State Railroad Museum.)

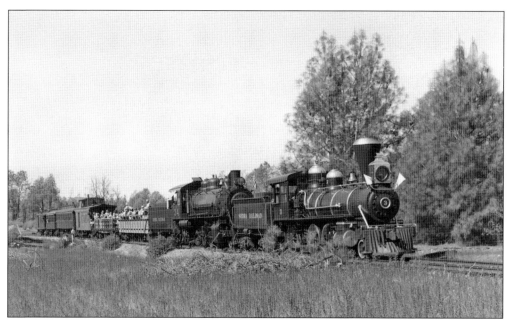

Aside from movies and television work, Sierra No. 3 was the hands-down favorite of railfans, who came to the Jamestown Shops as early as the 1930s to admire steam railroading in action. This 1951 photograph, taken only a few years after No. 3 was restored, shows it (aided by Sierra No. 34) pulling a substantial train. (California State Railroad Museum.)

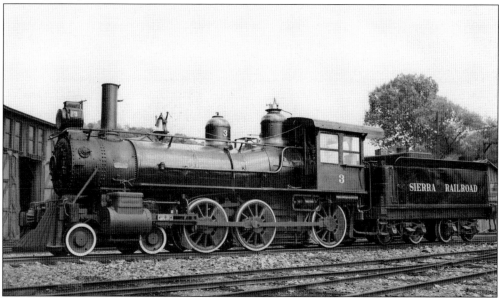

No. 3 is pictured here at the roundhouse in 1950 during a period when the locomotive was dividing its time between movie work and special excursions. No. 3 (shown here during television work in 1950) and the Sierra Railroad in general were appealing for the following reasons: the real steam from the smokestack, the genuine historic cars behind the locomotive, the period water tank (apparently at Jack's Siding), and the lonesome period car on the side track. There is no mystery as to why No. 3 may be the most photographed locomotive in the United States! (California State Railroad Museum.)

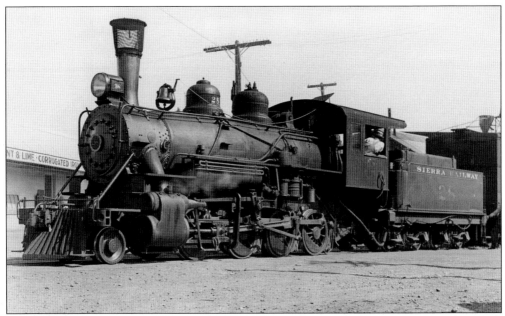

Sierra No. 28 is the second-most famous steam locomotive at the Railtown 1897 facility. Built in 1922 by the Baldwin Company, this 2-8-0 (two leading wheels, eight driving wheels, and no trailing wheels) was produced specifically for use on the Sierra Railway. Here, Sierra No. 28 pulls a freight load at the station in Oakdale in the 1920s. (California State Railroad Museum.)

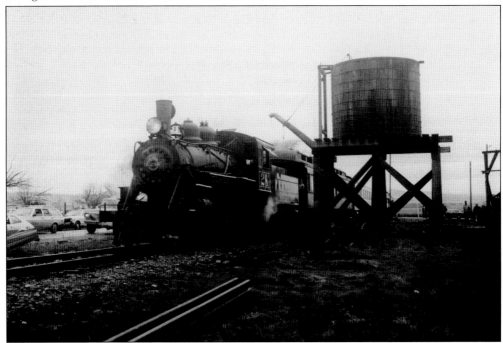

Sierra No. 28 was a crowd favorite after World War II, when railfans began to book steam-train excursions. Here, No. 28 is being used in a May 1959 excursion and appears to be at the same Warnerville water tower depicted in a photograph on page 15. (California State Railroad Museum.)

Although No. 28 was used in movie work and railfan excursions, it was also busy with freight hauling right up to the time the Sierra Railroad was dieselized in 1955. In this photograph, No. 24 and No. 36 are pulling a very long freight train somewhere between Jamestown and Oakdale. No. 28 is in the center of the train. (California State Railroad Museum.)

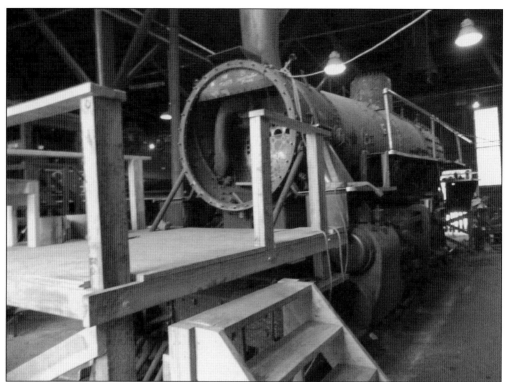

Maintaining a steam locomotive like No. 28 requires periodic major maintenance work. The workhorse locomotive is shown here at the Jamestown Shops undergoing full repair and restoration for continued service on the Railtown excursions and, likely, movie work as well. (Photograph by Stephen D. Mikesell.)

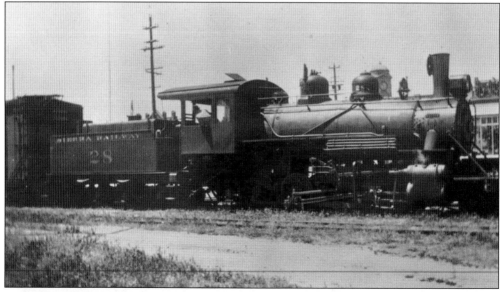

In the late 1970s, another locomotive briefly carried No. 28. Short Line Enterprises brought its 4-4-0 to the Sierra Railroad. It was soon renumbered as Sierra Railroad No. 8. (California State Railroad Museum.)

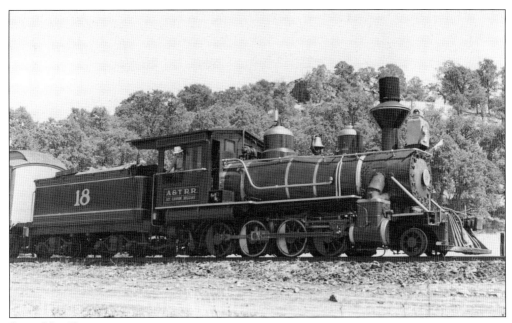

Sierra No. 18, a Baldwin 2-8-0 (two forward wheels, eight power wheels, no trailing wheels), was bought new by the Sierra Railway in 1906, not long after the line was expanding into Sonora and Angels Camp. Shown here in 1940, Sierra No. 18 is at the station in Cooperstown, painted for movie work. No. 18 was retired in 1953, sold by the Sierra Railroad in 1966, and still exists in Oregon. (California State Railroad Museum.)

This is another view of Sierra No. 18. This undated photograph was likely taken at the same time as the previous photograph of a 1940 movie shoot. (California State Railroad Museum.)

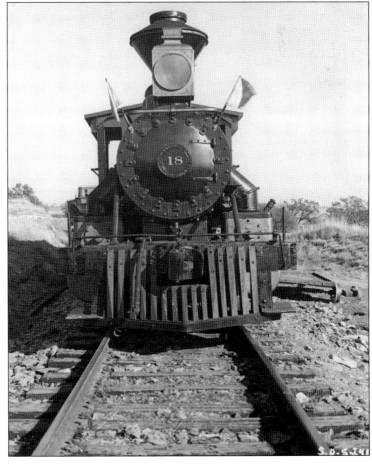

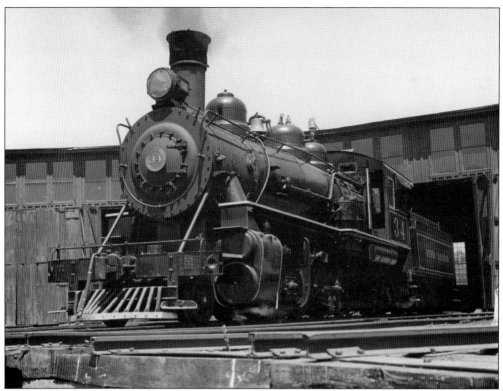

Sierra No. 34 is a longtime working sister of Sierra No. 28, although it has a 2-8-2 configuration. It was built in 1925 by the Baldwin Locomotive Works and is original to the Sierra Railway system—that is, it has only been used on the Sierra Railway. (California State Railroad Museum.)

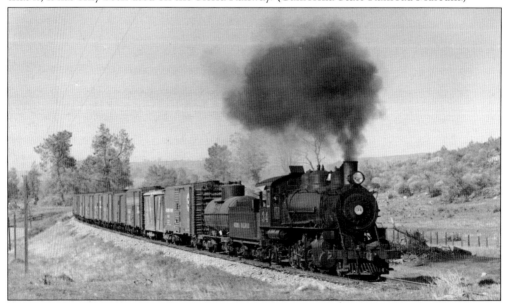

Here, No. 34 is hauling a substantial freight train between Oakdale and Jamestown. This photograph was taken in 1954, a year before the Sierra Railroad was dieselized. (California State Railroad Museum.)

The Sierra Railway also purchased several gear-driven locomotives for use on the steep and winding Angels Branch and the steep line between Jamestown and Tuolumne. Among these were three Shays and one Heisler. Unfortunately, only one of these gear-driven locomotives still exists, although the Jamestown Shops does include a Shay acquired by the Pickering Lumber Corporation. One of these gear-driven locomotives was Sierra No. 11, a two-truck Shay built by the Lima Locomotive Works in 1903 and often used on the Angels Branch. Here, No. 11 pauses at the depot in Jamestown, pulling cars No. 5 and No. 6, ready for a run on the Angels Branch. (California State Railroad Museum.)

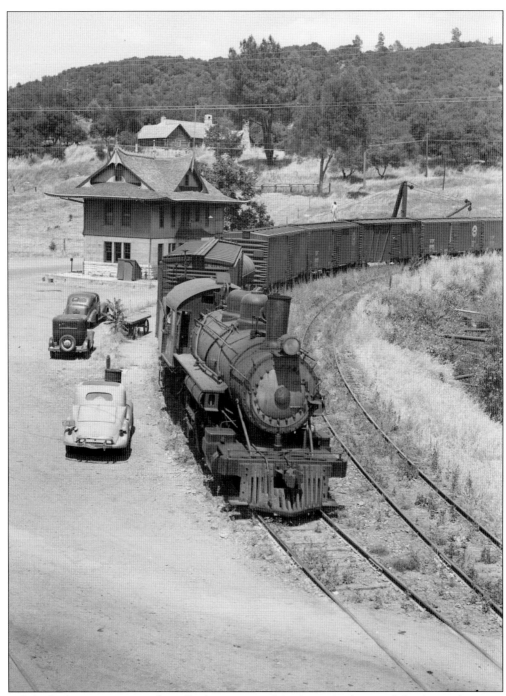

While the locomotives were literally the engines of the Sierra Railway and the focus of greatest interest among railfans, the steam railroading experience of the Sierra represented the blending of many factors—the locomotives, of course, but also the freight and passenger cars, as well as the railroad structures and the natural and cultural setting for all of these. The totality of the steam railroading experience is captured nicely in this photograph of Sierra No. 24 pulling a long train of freight cars alongside the handsome depot in Sonora. (California State Railroad Museum.)

Six

OTHER ROLLING STOCK

Apart from its locomotives, the Railtown 1897 collection of heritage railroad equipment includes a remarkably complex mix of freight cars, passenger cars, track cars, and other types of railcars, nearly all of them used historically on the Sierra Railway operation. The diversity of the Railtown collection reflects the range of functions of the Sierra Railway. The Sierra Railway was founded to service the extractive industries of Tuolumne and Calaveras Counties and to provide passenger services to these isolated communities.

When the State of California took over the Jamestown Shops and Yards in 1982, a large collection of the old rolling stock was still in place. The steam locomotives, of course, were the most prized possessions taken over by the state. To many, the passenger cars were also highly prized because they were people-oriented and because they had been used in many movies. For many serious students of railroad history, however, the workaday pieces of rolling stock—side-dump cars, hopper cars, boxcars, and track cars—are equally valuable, because they depict the full story of historic steam railroading. The railroad fan visiting Railtown 1897 should save enough time to go beyond the roundhouse and steam locomotives to visit these other aspects of the collection. These seemingly utilitarian pieces of industry from the late-19th and early-20th centuries have equally important stories to tell.

Among the workaday cars, the Railtown 1897 collection includes a very diverse group of side-dump cars. Side-dump cars, as their name suggests, could tilt the bed and dump a load to one side through an air-powered piston apparatus. Here, a group of these cars dumps fill to create a crossing for Woods Creek near Sonora. The Shay Sierra No. 11 is shown here in 1918 with one generation of side-dump cars. Apart from their work in maintaining the Sierra's own trackage, side-dump cars were also useful in the major construction projects the Sierra Railway helped with, including the building of major dams on the Stanislaus and Tuolumne Rivers. The Railtown collection includes more than a dozen very old side-dump cars. (California State Railroad Museum.)

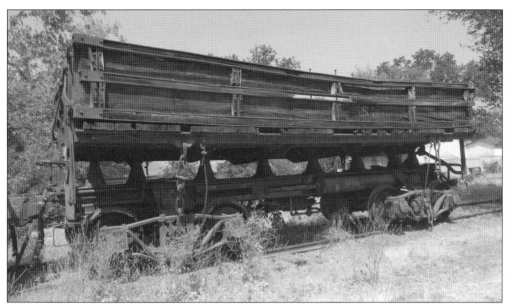

This is a modern view of a side-dump car still in the collection at Jamestown. This wooden-bodied car, Sierra No. 197, was built in 1907 by the Western Wheeled Scraper Company. It and three other side-dump cars were operated by the Palmer & McBryde Construction Company of San Francisco, which was involved in highway construction, levee construction, and other jobs requiring moving massive amounts of dirt and gravel. These cars were purchased by the Sierra Railway in 1939. (Photograph by Stephen D. Mikesell.)

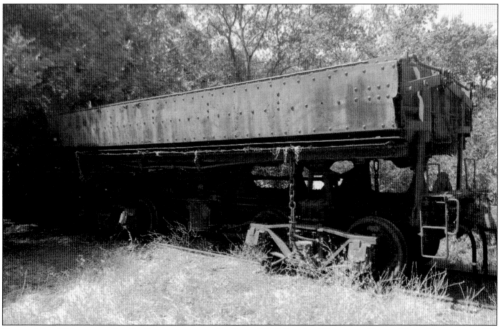

Sierra No. 191, a metal side-dump car, was built in 1914 for the Yosemite Sugar Pine Company. All of the side-dump cars in Jamestown were produced by the Western Wheeled Scraper Company, an Illinois firm that specialized in road scrapers but also built railroad cars. (Photograph by Stephen D. Mikesell.)

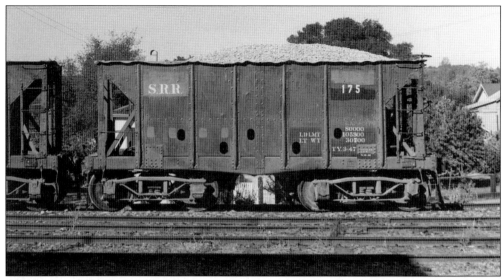

Another type of working car held in great numbers in the Railtown 1897 collection is the hopper car. These cars could be filled from the top and discharged from the bottom, making them extremely useful in carrying construction material such as the aggregate that was used to build the big dams on the Stanislaus and Tuolumne Rivers. This particular group of hopper cars—former Great Northern iron-ore cars built in 1899–1900—was acquired in 1924 specifically for the Melones Dam project on the Stanislaus River. (California State Railroad Museum.)

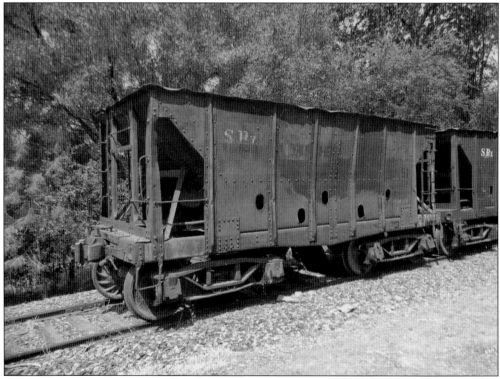

The hopper car in this modern photograph is very similar to the one shown in the historic image at the top of this page. (Photograph by Stephen D. Mikesell.)

70

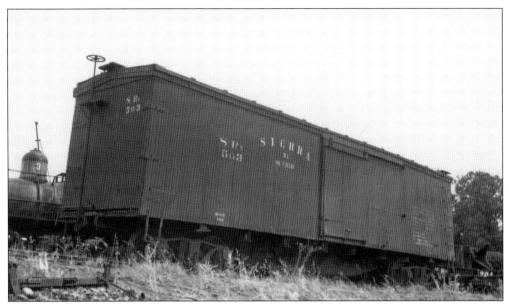

Over the course of its life, the Sierra Railway also used a number of boxcars to carry cargo best not exposed to the elements. The line bought a dozen or so boxcars—some new, but many purchased from other rail lines. Secondhand boxcar No. 503 is shown here in 1937. (California State Railroad Museum.)

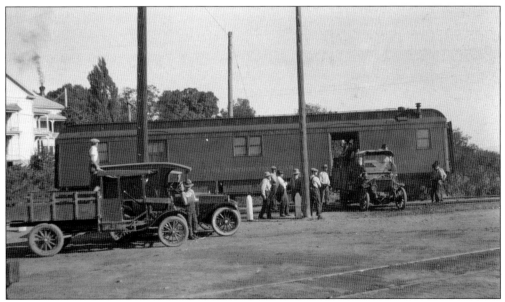

Trucks pull up to the baggage door of a converted baggage car in Sonora in this 1920s photograph. Barely legible on the boxcar is the inscription "California Fish and Game Commission, Fish Distribution Car." The car, owned by the State of California, carried fingerling trout for planting in Sierra Nevada lakes and streams. These cars traveled all around California, from fish hatcheries to locations in the mountains. (California State Railroad Museum.)

To many observers, the passenger cars of Railtown 1897 are among its most valued elements. The passenger cars are also among the most unusual parts of the Railtown collection, particularly the cars that were designed specifically for use on the Angels Branch. The passenger usage on the Sierra Railway was never great, but it was much cherished by the residents of Calaveras and Tuolumne Counties, which were quite isolated during the period of steam service. The crown jewels in this regard are Sierra No. 5 and No. 6, short-bodied passenger cars built by the Holman Car Company of San Francisco for use on the Angels Branch. Car No. 5 is a combination baggage and passenger car; car No. 6 is a passenger car. The two ordinarily traveled together on the hair-raising alignment of the Angels Branch. They are shown here being pulled by Sierra locomotive No. 9, a gear-driven Heisler. The short passenger train is stopped at the modest station at Carson Hill, just north of the Stanislaus River crossing. (California State Railroad Museum.)

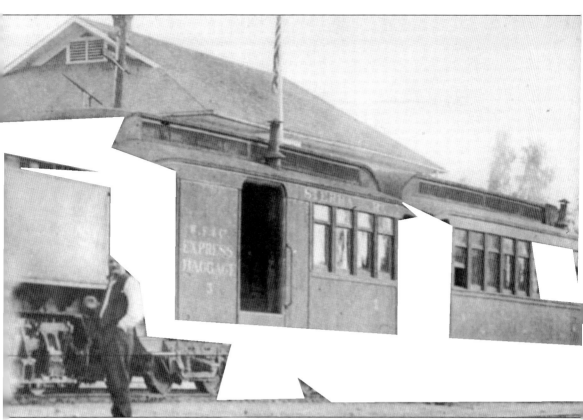

Not surprisingly, the passenger traffic between Jamestown and Angels Camp was rarely large enough to warrant carrying passenger cars alone. Not uncommonly, cars No. 5 and No. 6 were assembled as part of a mixed train, with freight and passenger cars making the trip together, as shown here. Car No. 6 is at the rear, and No. 5 is just in front of it. The exact location of this photograph has not been identified; it appears to be the Sierra Railway depot in Angels Camp, which still exists but is now a private residence. (California State Railroad Museum.)

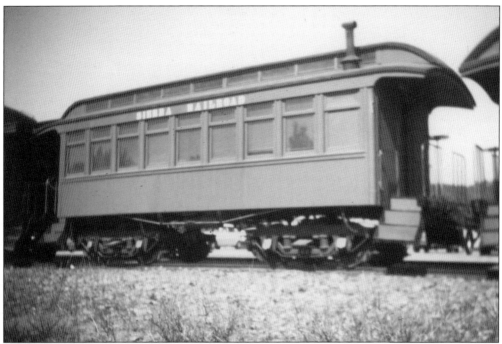

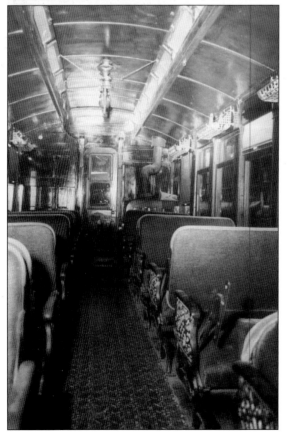

Sierra No. 6 was a standard passenger car fitted on a somewhat shorter chassis to accommodate the Angels Branch alignment. It is still in almost-mint condition and is often used on film shoots. No. 6 was built in 1902 by the W.L. Holman Car Company, a San Francisco firm best known for creating the San Francisco cable cars. This car was specifically built for use on Angels Branch, which, because of its many switchbacks, required a shorter car than usual. The car served Angels Branch passengers until the line closed in 1935. It was then used on the Hetch Hetchy Railroad until that line closed in 1949. (California State Railroad Museum.)

Car No. 6 features an intact interior, making it an especially popular item for Western films. One of the truly infuriating aspects of film history, however, is that directors sometimes found it more economical to build a replica of a railcar in a sound studio than to use the real thing. Many films seem to feature car No. 6's interior, although some may actually be using studio copies of its interior. (California State Railroad Museum.)

Sierra No. 5 had a baggage room at one end and a small passenger compartment at the other. By custom, smokers (almost always men) were asked to use the limited seating on Sierra No. 5, leaving Sierra No. 6 for families and nonsmokers. This car was built in 1902 by the W. L. Holman Car Company, which also built car No. 6. There are dozens of photographs of No. 5 and No. 6 together, although there are perhaps as many of Sierra No. 5 serving as caboose and passenger car in a very light traffic day on any one of the Sierra Railway's freight and passenger lines. (California State Railroad Museum.)

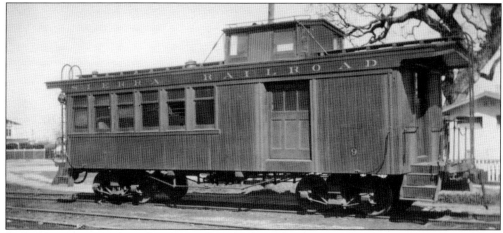

Sierra No. 9 was an altogether unusual car built in the shops at Jamestown for the specialized needs of the passengers on the Sierra Railway. It was not built for the Angels Branch; it is slightly longer than Sierra Nos. 5 and 6. Instead, it was built at the Jamestown Shops in 1914 for the even more limited passenger service on the run from Jamestown to Tuolumne. Designed as the end car of a mixed freight-passenger train, Sierra No. 9 was a passenger-baggage combination (like No. 5), but it also included a caboose cupola. If not unique, it is a highly unusual combination caboose-passenger, car-baggage car. It is currently under restoration at the Jamestown Shops. (California State Railroad Museum.)

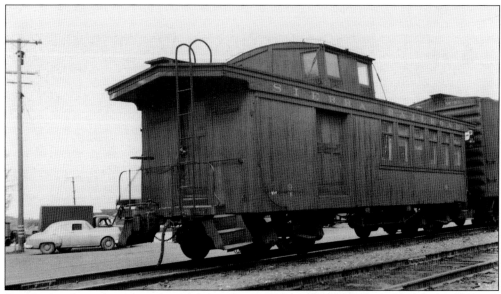

Car No. 9 is shown here in use strictly as a caboose at the end of a freight train in the early 1950s. A short line like the Sierra learned to be flexible and use its equipment—now seen as precious by railroad historians—in whatever manner an operation required. This unconventional car was designed and built at the Jamestown Shops for a highly unusual function. (California State Railroad Museum.)

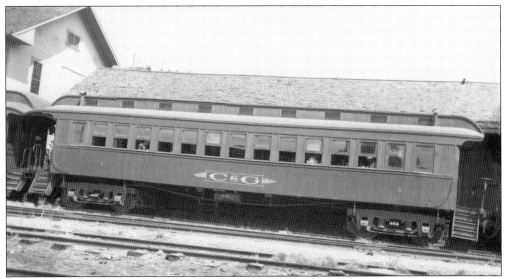

Sierra No. 2, a far more substantial passenger car, was put into use by the Sierra Railway after 1929; it is still operable and in use today. This long car was built by the Watson Manufacturing Company in 1869 for use by the Central Pacific Railroad on the line from Sacramento, California, to Ogden, Utah. Over the next 80 years, it was used and reused throughout California. The car was sold in 1912 on the Ocean Shore Railroad, a short-lived railroad extending from San Francisco to the Santa Cruz area. In 1919, it was acquired by the Hetch Hetchy Railroad. In 1929, the Sierra Railway acquired the car for use in the movies. Apart from cars No. 5 and No. 6, car No. 2 is the most popular Sierra passenger car used in movies. Here, No. 2 is painted for use in the 1938 film *In Old Chicago*, starring Tyrone Power and Don Ameche. Behind the car is the freight shed, and the second-generation Jamestown general office is on the left. (California State Railroad Museum.)

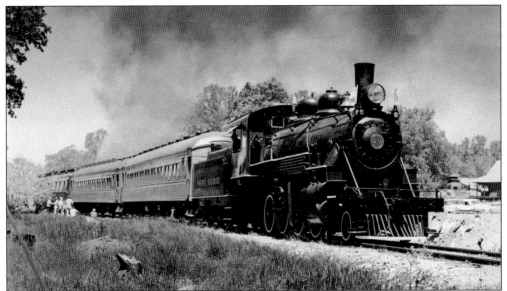

Instead of the precious wooden passenger cars, rented steel passenger cars from Southern Pacific or Santa Fe are generally used for most excursions. In this 1958 excursion, a string of long steel Southern Pacific cars is pulled by locomotive No. 28. (California State Railroad Museum.)

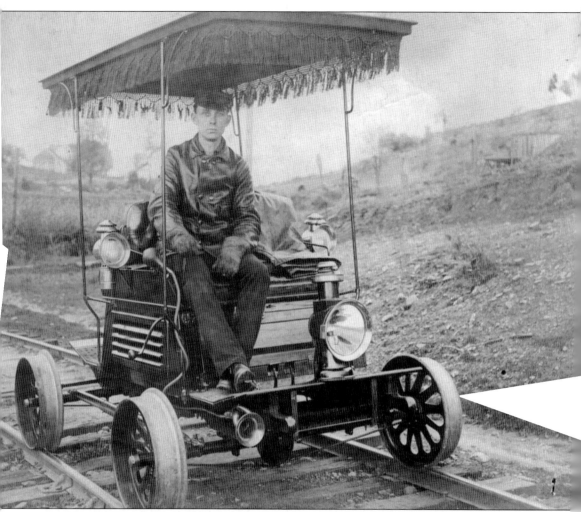

In addition to passenger and railcars, the Sierra Railway relied on a large number of specialty cars for specific purposes. One such purpose car was a speeder, used for inspecting track and bridge conditions along the line. A small speeder, ordinarily powered by a gasoline engine, could be controlled by a single driver, limiting the cost of using large, steam-powered vehicles for mere maintenance work. One of the early Sierra examples is this Oldsmobile canopy-topped speeder being driven by Joseph Hugo Marchand. (California State Railroad Museum.)

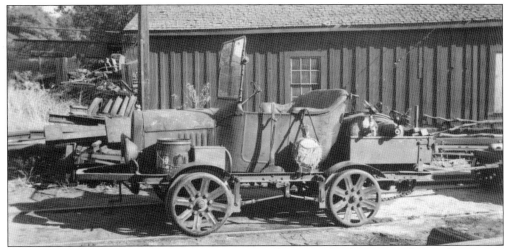

Railtown 1897 in Jamestown has one of the largest collections of authentic speeders in the country. Most are gasoline-powered, and several are simply gasoline-powered road vehicles adapted to move on tracks. One example is the Sierra No. 8 speeder, assembled in the Jamestown Shops at some point in the 1920s. The engine and body, taken from a Ford Model T, were assembled on a speeder chassis built by Fairbanks-Morse, a diversified manufacturer that originated in Wisconsin. The Sierra roadmaster (the maintenance chief for the right-of-way) used No. 8 on his inspection trips, checking the railroad track, bridges, and structures up and down the line. Last regularly used in the 1940s, No. 8 never left the Sierra Railway and is operable today. It had a regular part in the television series *Petticoat Junction*. (California State Railroad Museum.)

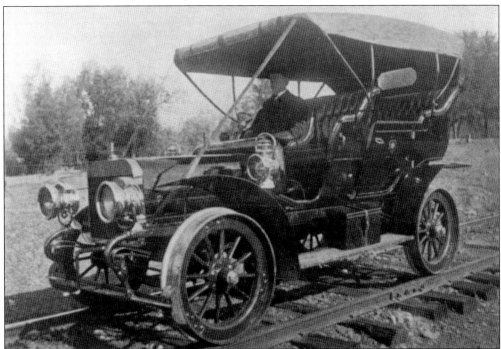

The Sierra Railway used a number of different track cars that were adapted from automobiles. None was more impressive than this right-hand-drive vehicle, about which little is known except that it was a track car used on the Sierra Railway. (California State Railroad Museum.)

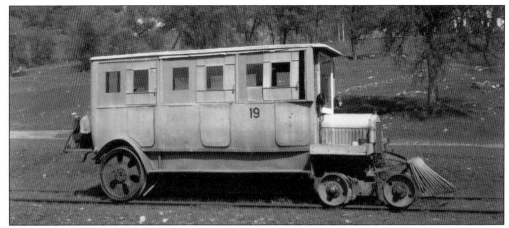

Perhaps the most unusual of all the cars in the Railtown collection, Hetch Hetchy No. 19, was built by A. Meister & Sons Company of Sacramento using a White Motor Company three-quarter-ton truck chassis and finished off by the City of San Francisco's Municipal Railway shops for the city-owned Hetch Hetchy Railroad. Acquired by railfan Al Rose in 1949, when the Hetch Hetchy was abandoned, the car was donated to Railtown by his widow, Helga Rose, in 1997. The car resides at the Jamestown Shops and is occasionally taken for a ride. Hetch Hetchy 19 is shown here when it was still in service on the Hetch Hetchy Railroad. (California State Railroad Museum.)

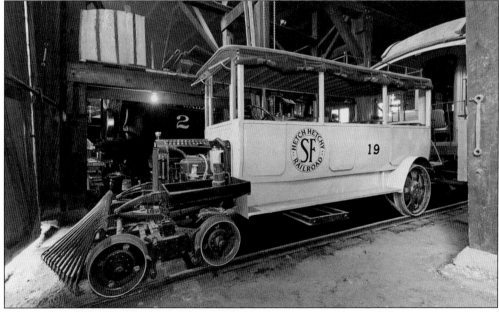

A. Meister & Sons Company manufactured horse-drawn carts at first and, later, various types of automobile bodies. In 1918, the firm was located in Sacramento, but, a few years later, it moved to Woodland. This vehicle is as much a self-propelled touring bus as it is a railcar. It was built for the Hetch Hetchy Railroad, which was completed in 1918. That railroad was primarily a construction-related line, but it did offer tours to an otherwise remote part of Yosemite National Park. The railroad line referred to this vehicle, which served several functions for the line, as a "track bus." It had two rows of comfortable seats, which could be occupied by those invited to view construction of the Hetch Hetchy Dam. The car could also act as an ambulance with a stretcher fitted over the rows of seats to transport injured workers to area hospitals. (Railpictures.net.)

Seven

THE MOVIE TRAIN

The Sierra Railway property is nationally significant in two regards. First, the Jamestown facility retains an amazingly intact group of railroad buildings and steam-era rolling stock. Second, the railway is important because it is likely the most filmed railroad system in the United States—and, perhaps, in the world. This second development relates to the fact that the California-based film industry discovered the scenic beauty of the Sierra Railway and its landscape as early as the late 1910s. The use of the line by moviemakers accelerated after World War II and was arguably at its highest level of activity in the 1950s. Filmmaking has been done on the Sierra line since the early days of motion pictures, and it continues today.

Not surprisingly, the vast majority of films made on the Sierra Railway have been Westerns. By the late 1950s, for example, most steam trains had been destroyed, making it very difficult to recreate the scenery and equipment that characterized railroading in the Old West. The wide-open spaces along the Sierra, combined with the authenticity of the rolling stock and shops, made it especially attractive to directors of Westerns. In time, the facility became as popular among television producers as it was among film producers for roughly the same reasons: its intact steam-era equipment and buildings and the Old West feel of the countryside.

In the early years of filmmaking, steam was still the only means of railroad propulsion, and the locomotives and passenger cars of the Sierra Railway were only a few decades old. In the 1920s, the Sierra Railway could be used to depict almost any small-town setting in America. In this scene from the 1921 film *The Traveling Salesman*, Fatty Arbuckle waves to a crowd of well-wishers (most of them women) from the back of a Sierra Railway passenger car, possibly No. 3. At left are the second Jamestown depot and the 1897 freight shed. This was Arbuckle's last film before his career was derailed by a sensational rape trial. (Tuolumne County Historical Society.)

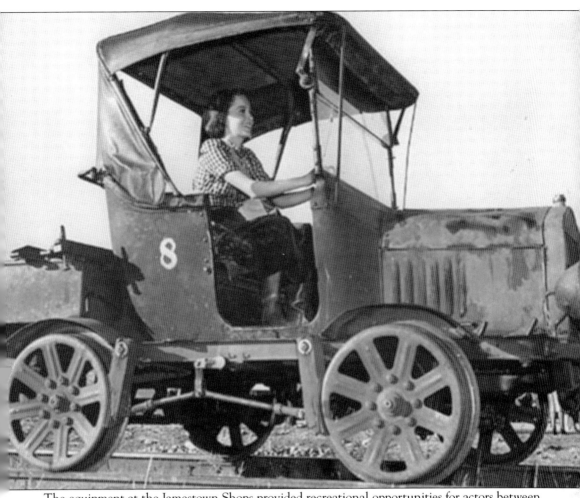

The equipment at the Jamestown Shops provided recreational opportunities for actors between takes. Here, Olivia de Havilland poses in the gasoline-powered car No. 8 during the filming of *Dodge City* in 1939. Her costar was Errol Flynn. No. 8 has a Ford Model T chassis and engine modified for rail use at the Jamestown Shops. (Tuolumne County Historical Society.)

It was the Western film that really made the Sierra Railway a star, and this photograph shows why. In this image, Sierra No. 3 is painted as a Union Pacific locomotive for the 1929 film *The Virginian*, and the rolling foothills of Tuolumne County stand in for the rangeland of Wyoming. That film is generally recognized as the first major Western "talkie" and the first talking film to feature Gary Cooper as a leading man. Sierra No. 3 was almost always fitted with a bulbous smokestack—a characteristic of a wood-burning locomotive—for its film roles. No. 3, however, burned fuel oil most of its life and featured a straight smokestack when it was not starring in a film. (Tuolumne County Historical Society.)

In this scene from *The Virginian*, horsemen discuss a situation with the engineer of Sierra No. 3. The rider closest to the engineer is Gary Cooper. Adapted from a Western novel of the same name by Owen Wister, *The Virginian* told the story of a Wyoming ranch foreman, known only as "The Virginian," who has to deal with a cattle-rustling gang that lamentably includes his best friend, a friend who meets a violent end because of his banditry. The movie closes with one of the world's best-known shoot-out scenes in a street by a saloon. Cooper made numerous films that were shot using Tuolumne County locales, films that usually also included Sierra Railroad equipment. (Tuolumne County Historical Society.)

ERROL FLYNN in "DODGE CITY" with OLIVIA DE HAVILLAND ANN SHERIDAN ~A Warner Bros. Picture

Film directors were attracted to the Sierra Railroad for its scenery as much its equipment. Access to wide-open spaces allowed filmmakers to simulate situations that would be nearly impossible to create in more settled areas. Here, Sierra No. 18 arrives at a staged "Dodge City" at Warnerville. The main line track in the foreground is buried in dirt to simulate Dodge City's end-of-the-line status. Warnerville never had a station; it was fitted with a large freight depot. Moviemakers built many temporary stations there, including the one shown here. *Dodge City*, released in 1939, was Errol Flynn's first Western and became one of the highest-grossing films of that year. (Tuolumne County Historical Society.)

The 1950s were a crucial time for establishing the Western movie as a popular form and the Sierra Railroad as a setting for almost any type of scene in such films. The Sierra worked well, for example, as a setting for train robberies, as shown in this scene from 1950's *Wyoming Mail*. The film, one of the earliest to star James Arness, was about train robbers—specifically, the robbery of mail from postal express services. The wooden baggage cars of the Sierra Railway were perfect for this genre of film. (Tuolumne County Historical Society.)

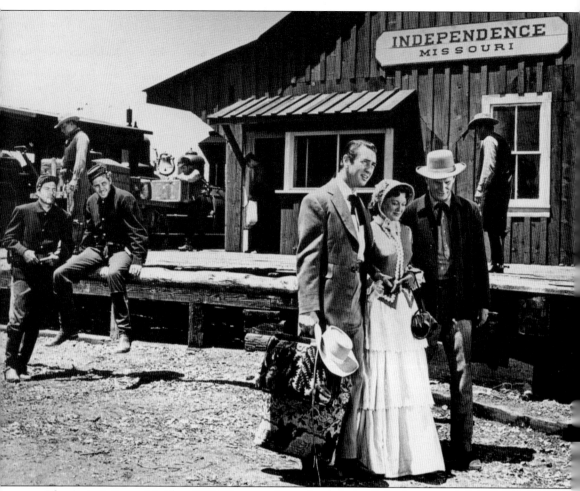

The Great Missouri Raid, a 1951 Western about the doings of the James and Cole brothers, was filmed at the Jamestown Shops. Here, the freight shed is painted to represent a station in Independence, Missouri. The actors standing in the foreground at right are Macdonald Carey (left), Ellen Drew (center), and Wendell Corey. This scene is especially useful as a record of what the Jamestown freight shed looked like in the early 1950s. It is the oldest building in Railtown 1897 and now serves as the key interpretive center for visitors. As California State Parks plans for the rehabilitation of this building, photographs like this should be exceptionally useful. (Tuolumne County Historical Society.)

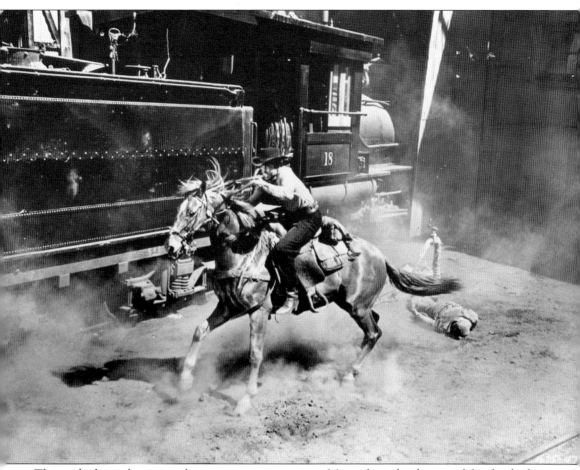

The yards themselves were also sometimes movie stars. Most often, the depot and freight shed were used as film sets, as shown on the previous page. Occasionally, however, the roundhouse and turntable were also utilized, as in this daring piece of horsemanship by Audie Murphy in the 1952 film *The Cimarron Kid*. Locomotive No. 18, shown here, was retired not long after this film was released. Murphy, one of the most heavily decorated American heroes of World War II, began his film career in 1948. *The Cimarron Kid*, about the Dalton Gang, was one of his earlier films and among the first of many Westerns in which he starred. (Tuolumne County Historical Society.)

Perhaps the best-known film to use the Sierra Railroad equipment and yards was 1952's *High Noon*, starring Gary Cooper and Grace Kelly. It was nominated for "Best Picture" at that year's Academy Awards. In the film, the menacing Frank Miller (Ian MacDonald) is to arrive in Hadleyville, New Mexico, and exact revenge for his earlier conviction to prison. Much of the Hadleyville scenes were shot in Columbia and Tuolumne County. The railroad scenes were shot at the Warnerville Station between Jamestown and Oakdale. This dramatic scene from the film is a production shot looking across the tops of numerous wooden cars on a long Sierra Railroad train approaching Warnerville, which played the part of Hadleyville Station in the movie. (Tuolumne County Historical Society.)

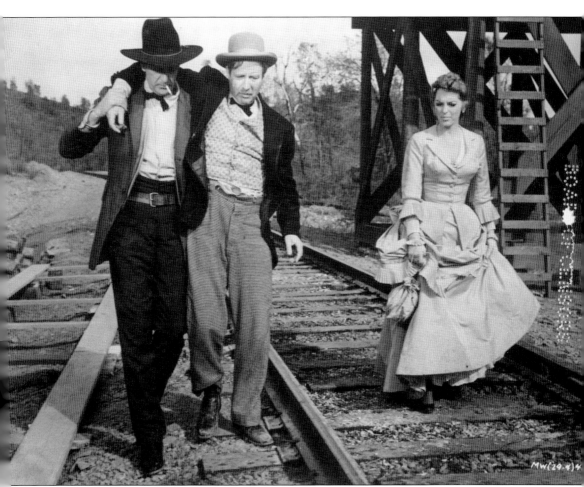

Gary Cooper may have starred in more films made on the Sierra Railway than any other major star. This extensive filmography included some of his earliest and some of his last Western films. This scene is from 1958's *Man of the West*, starring Cooper (left), Arthur O'Connell (center), and Julie London (right). Here, the three stars stumble by the water tower in Jamestown. The film concerns a train robbery that included theft of money that Cooper's character hoped to use to hire a schoolteacher in his remote Texas town. This movie was among the last made by Cooper, who stopped making films in 1961 due to health concerns. The film also featured Lee J. Cobb as the outlaw. (Tuolumne County Historical Society.)

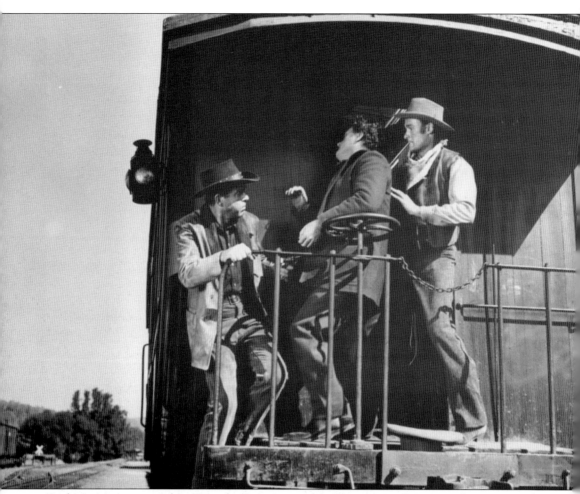

Fred MacMurray starred in *Face of a Fugitive*, another Western. MacMurray's character sought anonymity on the Western frontier after being falsely accused of murder. The murder follows a struggle on a train (pictured) that occurs early in the film. MacMurray (left) engages in fisticuffs on the platform of Sierra car No. 5, a combination passenger-baggage car that has been used many times in Western films. This 1959 movie made thorough use of the buildings and equipment at what is now Railtown 1897. The film also featured a young James Coburn. (Tuolumne County Historical Society.)

By the 1950s, television had begun to erode the monopoly that motion pictures held on action-based entertainment. Westerns and Western spoofs were popular in the early years of television, and the Sierra Railroad was at least as popular among television directors as among film directors. One of the most recognizable uses of Sierra equipment in a television series was in *Petticoat Junction*, a comedy that ran from 1963 to 1970. Sierra No. 3 played the part of the engine for the "Hooterville Cannonball," while the water tower in the Jamestown Shops played the part of an open-air bathing facility for Billie Jo, Bobbie Jo, and Betty Jo Bradley. Here, Sierra No. 3 is painted as the "Hooterville Cannonball," and its tender is labeled for the C&FW Railroad. The water tower is signed for the Shady Rest Hotel. (California State Railroad Museum.)

Another television Western that took full advantage of the Sierra Railroad and its setting was *Bonanza*, which ran from 1959 to 1973 (the second-longest-running television Western after *Gunsmoke*.) In this 1966 production photograph, the television crew lurks just off screen as Sierra No. 3 pulls a small load around a bend somewhere between Oakdale and Jamestown. (California State Railroad Museum.)

Lassie, which aired from 1954 to 1973, was another long-running television show that occasionally used the Sierra Railroad. Here, Lassie stands beside Sierra No. 3 in a 1971 episode of the show. (Tuolumne County Historical Society.)

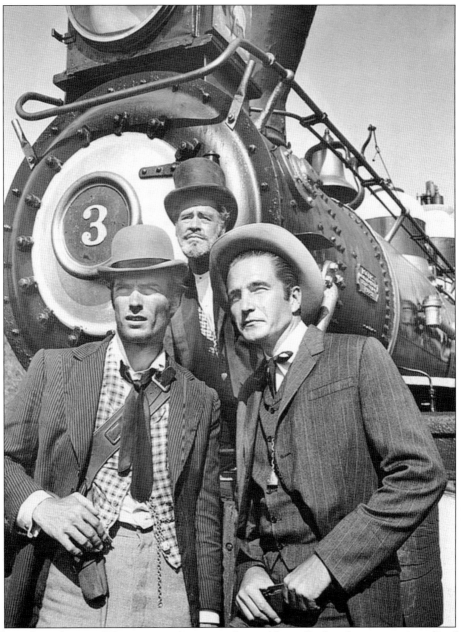

Still another television Western to make repeated use of Sierra Railroad equipment was *Rawhide*, which was broadcast between 1959 and 1965. The show, starring Eric Fleming, is best known for introducing the young Clint Eastwood to viewers. In this 1959 photograph, Eastwood (left); Paul Brinegar (center), as the wagon-train cook; and Fleming pose before Sierra No. 3 at the beginning of the series' long run. Eastwood, of course, went on to have a distinguished and active filmmaking career, including many Western films, some of which were shot using Sierra Railroad equipment. His 1992 film *The Unforgiven* was the only Jamestown-filmed movie to win an Academy Award for "Best Picture." When California State Parks sought funding to restore Sierra No. 3, Eastwood assisted in the fundraising, referring to the locomotive as being "like a treasured old friend." (Tuolumne County Historical Society.)

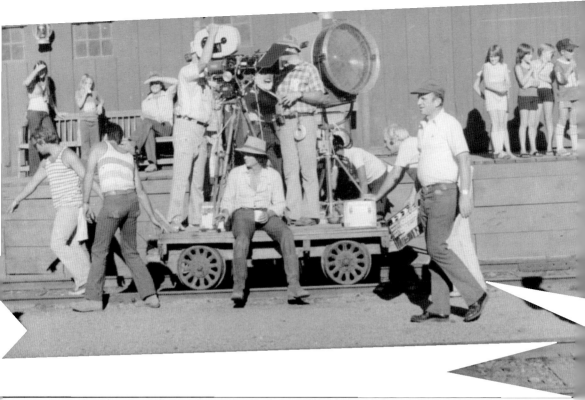

Little House on the Prairie, an exceptionally popular television show, made frequent use of the Sierra Railroad. The series, which ran from 1974 to 1983, was loosely based on the stories of Laura Ingalls Wilder. One reason for the long run of this show was the popularity of its lead, Michael Landon. He is shown here at center with the production crew on the set of a 1976 episode shot next to the freight shed. Landon, who also directed many of the series' episodes, came to the show after his work on *Bonanza,* another series that sometimes used Sierra Railroad equipment. (Tuolumne County Historical Society.)

Film and television work are part of the history of the Sierra Railroad and Railtown 1897. They are also part of its present and future. The versatile line was not restricted to appearing in Westerns, although that is surely what it does best and most often. The rolling stock and buildings in Jamestown can be made to resemble almost any steam-era place. In *Bound for Glory* (1976), a biography of Woody Guthrie, the steam engines of the Sierra could stand in for any town in America during the Great Depression. The actor David Carradine (pictured) played the part of Guthrie. Here, he is apparently serenading a Sierra steam locomotive—probably No. 3. (Tuolumne County Historical Society.)

The equipment and yards could also easily pass for Los Angeles in the 1910s, as in Peter Bogdanovich's 1976 film *Nickelodeon*, starring Ryan O'Neal (pictured). This film concerned a successful lawyer who gave up his career to become a writer and then a director in the silent films of early Hollywood. The film also starred Burt Reynolds and a young Tatum O'Neal. (Tuolumne County Historical Society.)

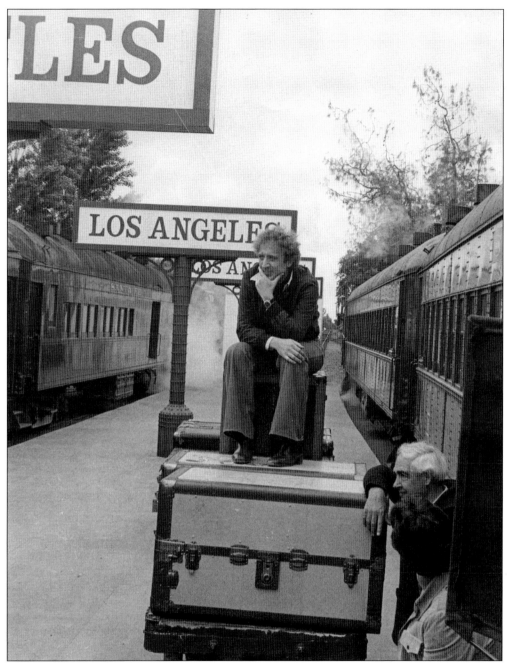

The Jamestown Shops also played the part of silent movie–era Los Angeles in Gene Wilder's 1977 comedy *The World's Greatest Lover*. In this film, Wilder plays the part of Rudy Hickman, a baker who dreams of making a career in film. He enters a contest a movie studio is holding in hopes of finding the next Rudolph Valentino. Despite a seemingly disastrous screen test, Hickman impresses the director, Zitz (played by Dom DeLuise), and his acting career begins. The scene depicted here, with Wilder at center, was shot immediately in front of the freight shed. (Tuolumne County Historical Society.)

Various movie and television history sources list different figures for the number of films and television episodes that involved the Railtown 1897 equipment, buildings, and setting. The State of California's website for Railtown 1897 includes a conservative list containing works that all sources agree upon. That list includes these films: *The Virginian* (1929), *Dodge City* (1939), *My Little Chickadee* (1940), *Young Tom Edison* (1940), *Santa Fe Trail* (1940), *Duel in the Sun* (1946), *High Noon* (1952), *Rage at Dawn* (1955), *Man of the West* (1958), *Rare Breed* (1966), *The Great Bank Robbery* (1969), *Great Northfield Minnesota Raid* (1972), *Oklahoma Crude* (1973), *Bound for Glory* (1973), *Nickelodeon* (1976), *East of Eden* (1980), *Shadow Riders* (1982), *Chattanooga Choo Choo* (1984), *Pale Rider* (1985), *Back to the Future: Part 3* (1990), *Unforgiven* (1992), *Bonanza: The Return* (1993), *Bad Girls* (1994), *Shaughnessy* (1996), *Song of the Lark* (2000), and *Redemption of the Ghost* (2000). Television shows are more difficult to count, since most are series, which might have filmed one or many episodes in Jamestown. Nonetheless, the conservative count from Railtown includes the following shows: *The Lone Ranger*, *Tales of Wells Fargo*, *Rawhide*, *Death Valley Days*, *Petticoat Junction*, *The Big Valley*, *The Wild Wild West*, *Green Acres*, *The F.B.I.*, *Iron Horse*, *Cimarron Strip*, *The Man from U.N.C.L.E.*, *Gunsmoke*, *Bonanza*, *Little House on the Prairie*, *The A-Team*, and *The Adventures of Brisco County Jr.* This photograph shows a collection of signs for different place-names that have been used for the freight shed/passenger depot in Jamestown in various movies and television shows. (California State Railroad Museum.)

Eight

EXCURSIONS, RAILTOWN 1897, AND A STATE HISTORIC PARK

During the 1930s, and especially in the years after World War II, the United States and Europe experienced a nostalgic embrace of old steam railroading. Those who were and are part of this phenomenon, which is only now beginning to attract scholarly analysis, are generally identified by the term "railfan." Whatever the emotional basis for being a train enthusiast, the fact is that railfans came into being as a national factor in the years just before and after World War II and are still very active. One of the principal railfan organizing groups in the United States was the Railway and Locomotive Historical Society (R&LHS), which formed in Massachusetts in 1923 and for which a California branch was organized in 1937. The R&LHS was active in saving antiquated rolling stock, especially old locomotives, throughout the United States. It was also an organizing apparatus for people who liked to see the railroad equipment of an earlier generation. The other major national railfan group is the National Railway Historical Society (NRHS), founded in 1935, which has over 160 local chapters across the country, including several in California.

These railfans, whether acting as individuals or as members of organizations, discovered the Sierra Railroad in the late 1930s. The popularity of the Sierra among railfans grew exponentially in the mid-1950s, when railroads throughout California began to destroy their steam operations, making the Sierra something of an unintentional museum of steam technology. Various groups of railfans began to organize "excursions," during which they would rent an entire passenger train on the Sierra Railroad and pay for it via tickets bought by the individual attendees. The R&LHS, NRHS, and other rail clubs were active in organizing many of these excursions, but other groups were involved, too. These excursions occurred almost annually from the 1940s through the early 1960s. They were halted in 1963, when the derailment of No. 28 during an excursion alerted the railroad to potentially costly accidents.

The excursion era on the old Sierra Railroad—from the 1930s through the early 1960s—was a time of showmanship, as the owners of the Sierra sought to satisfy the seemingly insatiable demand of railfans to experience steam railroading. At the time, working steam lines had virtually disappeared. This drive for showmanship led the Sierra owners to put together flashy excursions that used steam engines in ways rarely done during the working life of the lines, such as in this excursion, which has locomotives No. 3, No. 28, and No. 24 pulling what appears to be a small train of passenger cars. The owners of the Sierra teamed up three locomotives only on the rarest of occasions. (California State Railroad Museum.)

While the era of railfan excursions really took off after the line was dieselized in 1955, there is evidence that steam railfans had begun to flock to Jamestown much earlier. California chapters of national railfan organizations, such as the Railway and Locomotive Historical Society (R&LHS) and National Railway Historical Society (NRHS), were organized in the 1930s, and it appears that it was around that time that railfans began to show up in Jamestown. This photograph offers one of the earliest known views of railfans posing with Sierra Railroad equipment. These grinning railfans, identified as George Henderson (left) and Burt Ward, pose with Sierra No. 34 at an unknown location in 1937. (California State Railroad Museum.)

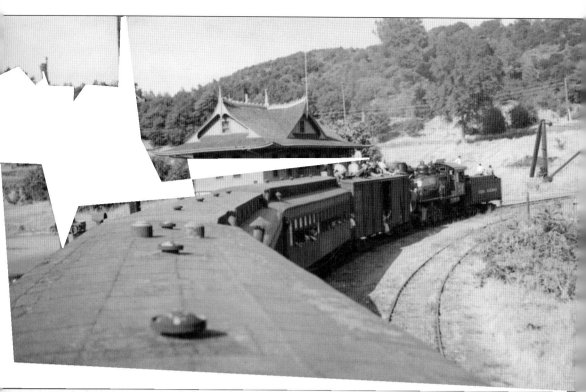

This photograph, also taken in 1937, again includes Sierra No. 34, indicating that this is probably part of the same excursion shown in the photograph on page 103. Note the dangerous positioning of railfans atop and inside a boxcar—this was not allowed or tolerated in later excursions. The excursion is passing by the Sierra Railroad station in Sonora, a very photogenic structure. Locomotive No. 34 is pushing this excursion train, indicating that there may have been another locomotive on the other end of the train, or that there was no opportunity for No. 34 to move from the rear to the front. (California State Railroad Museum.)

This photograph of an organized excursion shows Sierra No. 24 pulling a long train of at least seven passenger cars in May 1941, just months before the United States entered World War II. The photograph was taken at the end of the Sierra Railroad line in Tuolumne. (California State Railroad Museum.)

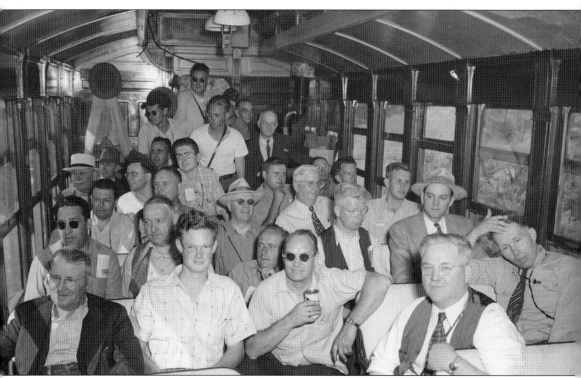

The previous photograph showed an excursion just prior to American involvement in World War II. The excursion shown here took place on the Hetch Hetchy Railroad in May 1947, two years before the line was closed and dismantled. The passenger car is almost certainly Sierra No. 6, which was sent to the Hetch Hetchy Railroad when passenger service declined and was discontinued on the Sierra Railroad. Note the absence of women in this photograph. Statistical studies of railfans today document that the vast majority are men; this trend apparently dates to at least the 1940s. (California State Railroad Museum.)

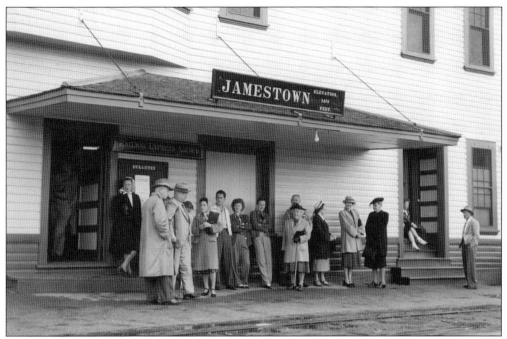

A small group of excursion riders waits at the station in Jamestown in 1948. Notes for this photograph indicate that this outing was organized by the Railway and Locomotive Historical Society (R&LHS). While most railfans are men, many women have participated in railfan events, as shown here. (California State Railroad Museum.)

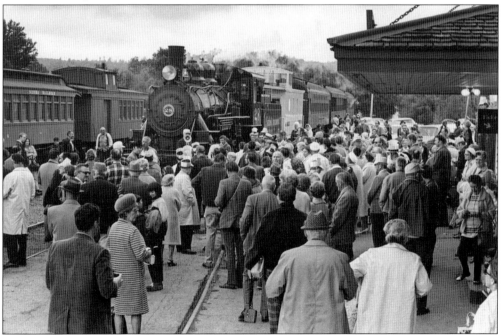

This photograph is not dated, but it may have been taken in the 1970s. It shows a much more impressive crowd of railfans—men and women alike—milling about the station at Jamestown, ready to board an excursion pulled by Sierra No. 28. (California State Railroad Museum.)

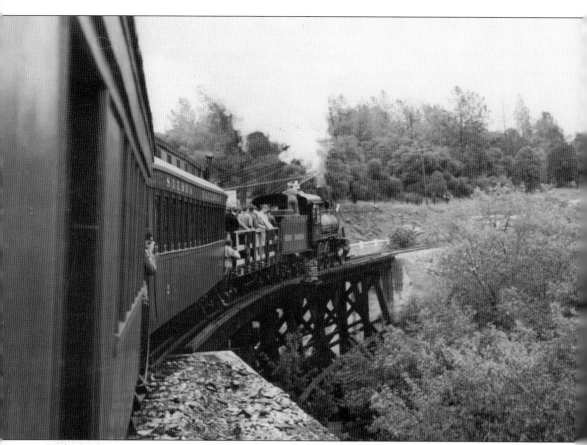

In this 1948 image, a recently-renovated Sierra No. 3 carries an excursion train over the Sullivan Creek trestle near Sonora. The train is eastbound. Despite the rain that day, the open flatcar behind the locomotive is crowded. (California State Railroad Museum.)

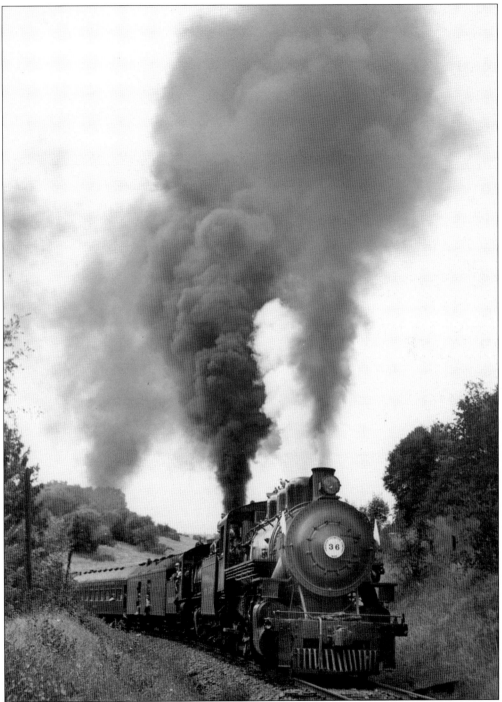

This 1948 excursion involved both No. 36 and No. 34. Doubling up steam locomotives for this relatively small train exhibits the showmanship that characterized the excursion era in the operation of the Sierra Railroad. Doubling the locomotives meant doubling the steam! Passengers dangle from the baggage car, a sight exclusive to early excursions. Later excursion rides—and those of today—prohibit this action. (California State Railroad Museum.)

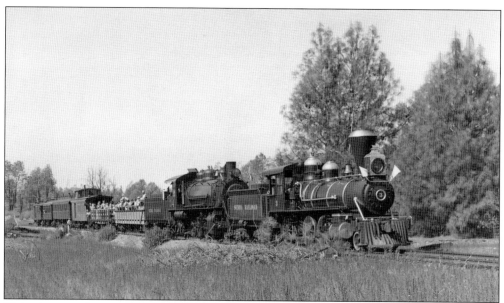

This photograph was taken in the fall of 1951. It shows the popularity of open cars and the excitement of seeing two steam engines—in this case, No. 3 and No. 34—pulling a single train. (California State Railroad Museum.)

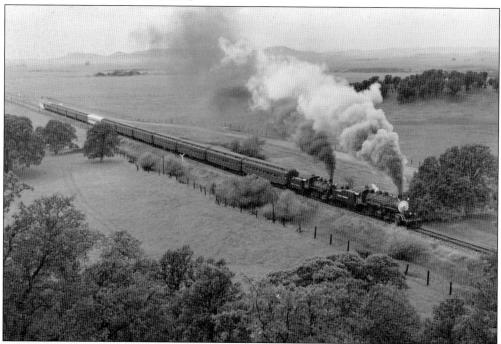

In 1955, the Sierra Railroad switched to diesel-electric locomotives and moved its diesel shops and yards to Oakdale. In a grand gesture to honor its steam past, and as a nod of gratitude to the loyal railfans who flocked to Jamestown, the Sierra Railroad organized a large-scale excursion called "Farewell to Steam." It was perhaps the biggest excursion ever organized by the Sierra. The train included two locomotives and 13 passenger cars. Although it was a sad event in many ways, the excursion was a railfan's dream! (California State Railroad Museum.)

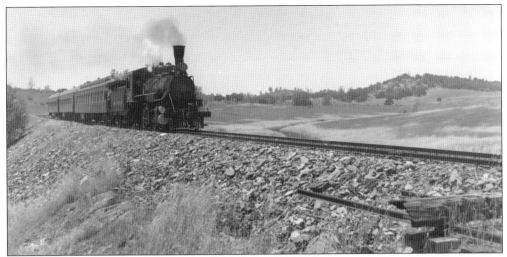

Although the 1955 tour was called "Farewell to Steam," the steam equipment did not go away, nor did the steam excursions. In fact, it appears that the dieselization of the Sierra Railroad may have actually increased interest in the steam operations, which were kept in good working order in the old shops in Jamestown. Here, Sierra No. 28 pulls a much smaller excursion train near Chinese Station. This excursion was organized by the Railway and Locomotive Historical Society in 1955. (California State Railroad Museum.)

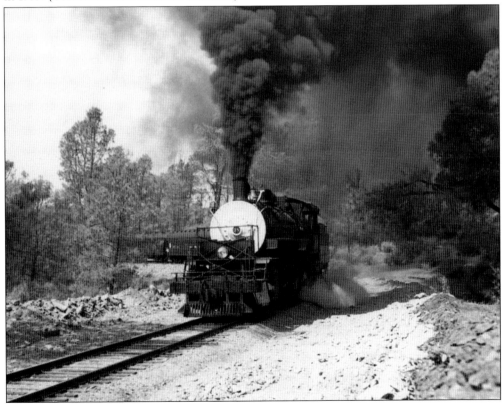

This 1955 railfan excursion is taking passengers from Jamestown to Sonora behind Sierra No. 38. (California State Railroad Museum.)

An excursion of railroad enthusiasts crosses the Black Oak Trestle on the Sierra Railroad in 1958. (California State Railroad Museum.)

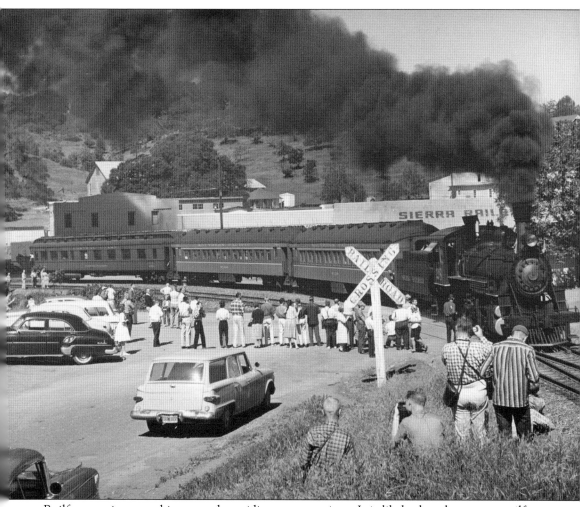

Railfans are interested in more than riding on excursions. It is likely that the average railfan spends more time photographing trains than riding them. This 1961 photograph likely shows both activities, with dozens of railfans snapping pictures of Sierra No. 28. The locomotive is making a "photo run by," in which the train is stopped to let passengers off; it then backs up and runs past them at speed, then returns to pick them up again. (California State Railroad Museum.)

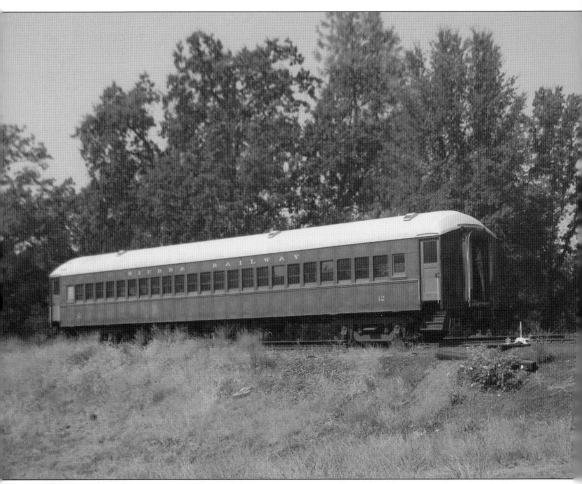

The excursion business was sidelined in 1963, when a railfan excursion train was derailed by an accident involving locomotive Sierra No. 28. The derailment caused the company to rethink the economics of excursions and cancel all such outings. However, the popularity of the rides in the 1950s and 1960s led the Crocker family—the owner of both the steam and diesel operations of the Sierra Railroad—to restart the tourist line in the 1970s. In 1970, Charles Crocker, grandson of Sierra Railway founder William H. Crocker, transformed the historic Jamestown Shops and Roundhouse complex into a tourist attraction he called "Rail Town 1897," featuring roundhouse tours and steam locomotive rides. Crocker also began to acquire historic rolling stock for use in the excursions. Many of these pieces, while historically interesting, are not part of the assembly of authentic Sierra Railway cars. Sierra car No. 12 (pictured) was built by the Pullman Company for the Southern Pacific Railroad in 1923. This beautiful car is useful for excursions, but it is not authentically related to the historic line. (Photograph by Stephen D. Mikesell.)

The *Glen Eyre* (pictured) was a private car built in 1899 by the Pullman Car Company and purchased by the Crocker family in 1972 as part of the general expansion of Railtown 1897. This originated as a private car for George Westinghouse, who founded the Westinghouse Corporation and was the inventor of the railroad air-brake system. In 1916, the car was sold as the president's car on the Western Pacific Railroad. (Photograph by Stephen D. Mikesell.)

In the early 1970s, the Crocker family Rail Town 1897 project undertook various impressive and ingenious promotions, such as this event celebrating the 75th anniversary of the founding of the Sierra Railway with a run between Jamestown and Cooperstown. This 1972 photograph, taken during the Charles Crocker era at Rail Town, shows a small excursion involving the facility's three most famous pieces of rolling stock: locomotive No. 3 and cars No. 5 and No. 6. (California State Railroad Museum.)

In the late 1970s, the Crocker family was planning to sell off the Sierra Railroad operations, and they began to float an idea of separating the diesel operation, which still carried freight, from the old steam operation in Jamestown. This proposal became a reality in 1982, when the State of California acquired the 26-acre Jamestown Shops, the existing buildings, and all of the historic rolling stock. Since 1982, the steam operation in Jamestown, its name modified slightly (to "Railtown 1897"), has continued to operate under the direction of the California Department of Parks and Recreation (or California State Parks). The park is operated by a handful of state employees and dozens—if not hundreds—of dedicated volunteers. State employees, contractors, and volunteers perform an amazing number of duties at the Jamestown Shops. For one, they maintain, and even rebuild, the old cars. Steam locomotives always required a great deal of maintenance; that was one reason diesel became so popular in the 1950s. In 2015, Railtown 1897 staff and volunteers rebuilt the great Sierra No. 28. Here, a worker welds a seam in the firebox for No. 28, which was under restoration at the time this book was written. (California State Railroad Museum.)

A volunteer works on the interior of parlor observation car No. 2901, which was built by the Pullman Car Company for Southern Pacific Railroad in 1910. Originally a wooden car, it was sheathed in metal in the 1920s. It served various Southern Pacific (SP) lines, including the SP-owned Northwestern Pacific and the San Jose–San Francisco commuter line. Southern Pacific donated the car to the Central Coast Railway Club, which sold the car to the Crocker family in 1971 to be used as part of the expansion of excursion service. The car came under state ownership when California State Parks took over the Jamestown property. (California State Railroad Museum.)

Volunteers man the trains for the ever-popular excursions. Railtown 1897 State Historic Park includes excursions as a major part of its interpretive program. The schedule changes with the seasons. At the time of this writing, the park offers train excursions four times a day on weekends from April to October, as well as popular themed rides on Valentine's Day, Halloween, and a special Christmas train. Shown here is a grand train of excursionists, with Sierra No. 3, Sierra No. 28, and Sierra No. 34 pulling passenger cars through the scenic countryside in rural Tuolumne County. This photograph likely predates the creation of the state park. (California State Railroad Museum.)

Railtown 1897 sponsors many special events, including the "Spotlight on Railtown" event held on July 20, 2013, and advertised on this poster. (California State Railroad Museum.)

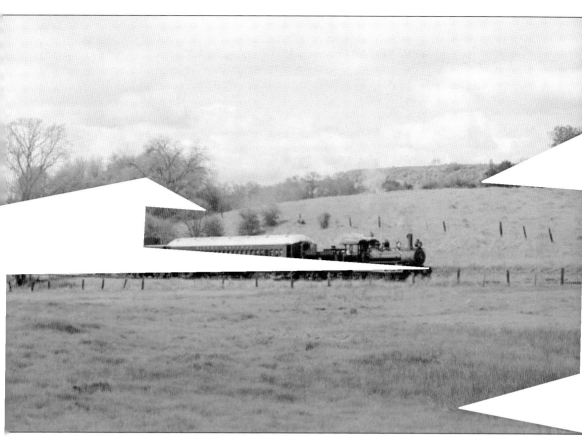

Some things have changed very little in the nearly 120 years that Sierra No. 3 and the rest of the Sierra Railway have been in operation. Taking a steam-driven train ride in the wilds of Tuolumne and Calaveras Counties was a thrill in the 1890s and early 20th century, and it remained thrilling to the early riders of excursion trains, as shown in the faces of riders in photographs from the 1940s. It is assuredly still exciting today, whether folks ride in Sierra No. 2 or in the cupola of the trailing caboose. There are few railroading thrills greater than to be pulled by the grand Sierra No. 3 through the greenery of Tuolumne County. This book offers a sample of what this priceless line has accomplished through the years. Visiting and riding on the line itself is the best and most authentic way to experience this magical piece of railroading history. (California State Railroad Museum.)

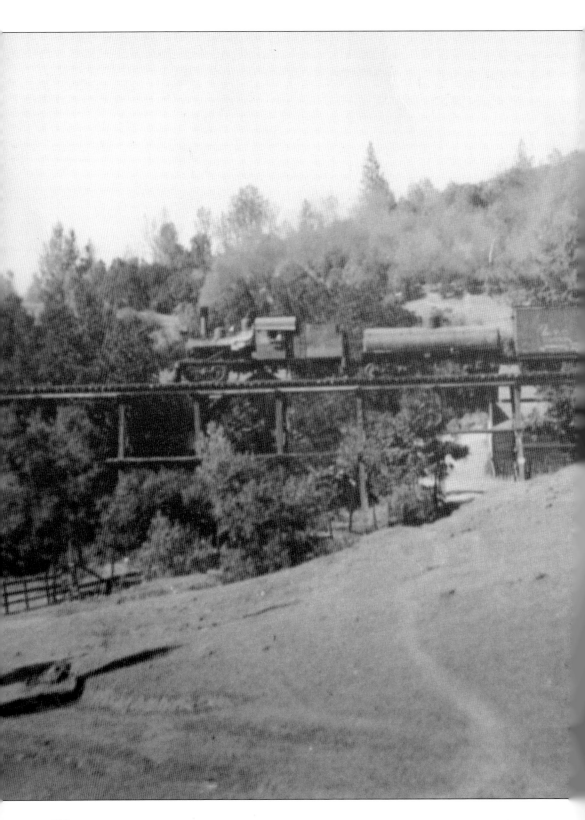

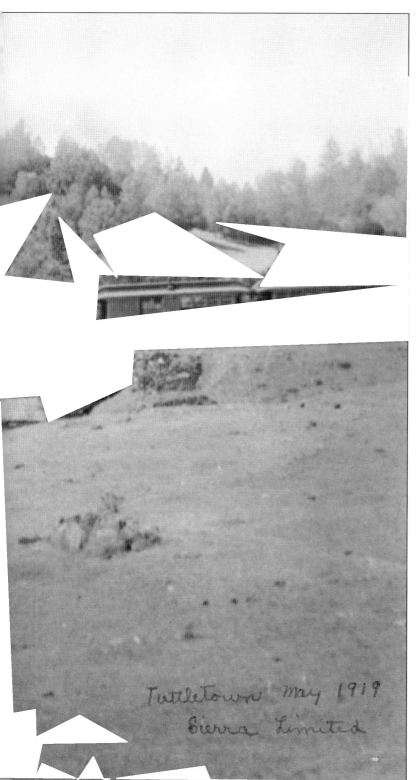

Tuttletown May 1919
Sierra Limited

For more than a century, the locomotives of the Sierra Railway/Sierra Railroad/Railtown 1897 have pulled wooden and metal cars along three major alignments: Oakdale to Jamestown; Jamestown to Sonora/Tuolumne; and on the Angels Branch. This photograph shows a mixed freight and passenger train crossing a large framed timber trestle at Tuttletown in Tuolumne County. The locomotive is the geared Heisler locomotive No. 9, long the standard Angels Branch engine. The two passenger cars are Sierra No. 5 and No. 6. Locomotive No. 9 was later owned by Standard Lumber company, and still later by West Side Lumber company. It was scrapped in 1947. (California State Railroad Museum.)

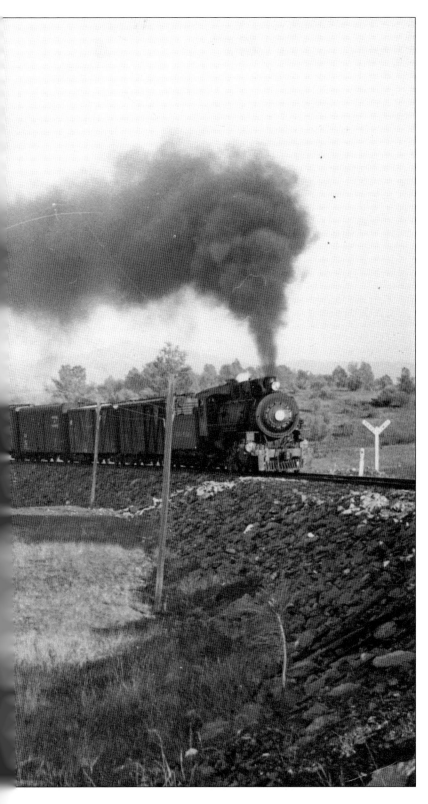

The Sierra Railway/Railroad locomotives also hauled extensive freight trains. In this photograph, most likely taken a few years before the line was dieselized in 1955, Sierra No. 24 and No. 36 are pulling a very long freight train somewhere between Jamestown and Oakdale. No. 28 is in the center of the train. (California State Railroad Museum.)

These same, familiar Sierra Railway/Railroad locomotives continued to power railfan excursions long after the regular passenger service had been discontinued and the freight service converted to diesel-electric power. This photograph shows a 1959 railfan excursion powered by Sierra No. 28. By the time this book is available to the public, Sierra No. 28 will likely be out of the shop and ready to join Sierra No. 3 and other locomotives in powering excursions operated by the State of

California. From the pioneering Sierra Railway to the mature Sierra Railroad to modern Railtown 1897, Sierra No. 3 and No. 28—and the other vintage equipment in the Jamestown Shops—have faithfully served both the people of Tuolumne County and visitors to the area. They stand ready to continue to serve long into the future. (California State Railroad Museum.)

DISCOVER THOUSANDS OF LOCAL HISTORY BOOKS FEATURING MILLIONS OF VINTAGE IMAGES

Arcadia Publishing, the leading local history publisher in the United States, is committed to making history accessible and meaningful through publishing books that celebrate and preserve the heritage of America's people and places.

Find more books like this at
www.arcadiapublishing.com

Search for your hometown history, your old stomping grounds, and even your favorite sports team.